Boston ICONS

Boston ICONS

50 SYMBOLS
OF BEANTOWN

Jonathan Scheff

gpp®

Guilford, Connecticut

Project editor: Kristen Mellitt
Text design/layout: Casey Shain

All photos by the author.

Library of Congress Cataloging-in-Publication Data is available on file.

ISBN 978-0-7627-4817-4

Printed in China

10 9 8 7 6 5 4 3 2 1

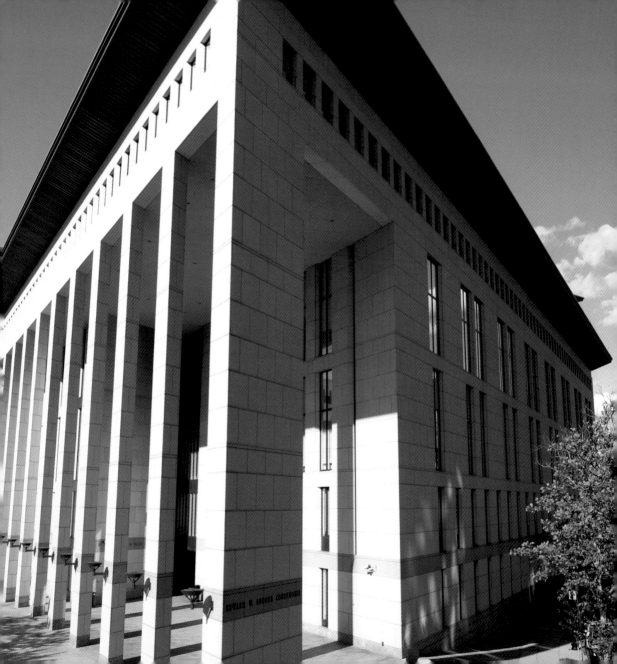

CONTENTS

INTRODUCTION

In the 17th century the hamlet called Muddy River began to grow on the outskirts of Boston, so named because of the two brooks that bordered it. In 1705 Muddy River became the town of Brookline, again named after the brooks that defined it. This is the town where, almost 3 centuries later, I grew up. (I was, in fact, among the last babies to be born at the Boston Lying-In Hospital before it closed its doors permanently.)

Brookline is a part of Boston—it has stops on the Green Line of the T; Beacon Street runs straight through it down to Newton; it is a cog in the massive, churning machine that is Boston— and yet it is also separate. It has its own culture and pace of life, slightly slower than the city. People from Brookline go to the Brookline Public Library, not the Boston branch, and it has separate soccer leagues, schools, and government.

So while I grew up in Boston, I also grew up outside Boston. When I went to the aquarium as a child, I went as a visitor—this was a strange, faraway land. To a small person the neighborhoods of Boston seemed so distant from each other, each its own sovereign nation: Chinatown, with the smell of pork buns drifting through the streets, and the North End, with children and adults hollering in Italian.

When I was older, and larger, the city shrank. I could walk from Chinatown to the North End quite easily, and I began to understand why people from London or New York would call Boston a quaint little town.

I left Boston at age 18, for Minnesota, Europe, Asia, California, New York. I've spent time in dozens of cities and towns, and it was only when I left Boston that I truly began to appreciate it. It is an accomplished, successful city, renowned for its intellectual and medical output; Massachusetts has also been the first to make major strides in certain national movements, most recently in gay marriage and universal health care; yet it seems so unassuming—proud of its accomplishments but not boastful.

Boston is also the epicenter of American history—another facet of the city that I did not truly notice until I moved away. When I was in grade school, we would take field trips to the USS *Constitution,* to the reenactment of the battle at Lexington and Concord, to Georges Island, to Plimoth Plantation. This seemed standard— somewhere in the back of my mind, I assumed that students everywhere study local history and visit important, pertinent sites. But students

in California, Kansas, and Wisconsin all learn about the battle at Lexington and Concord or the Boston Tea Party; in hindsight I feel extremely grateful that I had access to so much of American history in my backyard.

I feel a soft, subcutaneous pride for Boston, for Cambridge, for Massachusetts as a whole. And yet Boston does receive its share of criticism—well, all cities do, really. Many visitors call the city segregated or racist, and some Americans—especially outside New England—feel that the city has retained too many rigid, Puritan values.

These criticisms could be true or false, for all I know. I have to admit, while writing this, that my experience of Boston was specific to my life in Brookline and, even more importantly, to my parents. I was extremely lucky to have the parents that I did. So is Boston racist? Possibly. Socially conservative? Maybe. I honestly don't know.

What I do know is that a person's experience of Boston seems to vary much more than with other cities. Everyone has a different impression of New York, for example, but there is some general consensus about it: busy, crowded, exciting, with a large financial sector and a diverse group of artists. Boston seems to elude such characterizations.

It is equally considered large and small, exciting and dull, segregated and integrated, creative and unimaginative. In New York it is easier to find your niche—the inundation of people, events, and information is so constant that you can very easily jump into and out of the stream at different points. In Boston the life of the city exists less as a constant flow and more as a series of lakes, each with its own ecosystem. Thus your experience of Boston depends on which lakes you happen to find first.

As an adult I make a point to experience more of the niches of Boston than my native nook of Brookline. And the more I learn about Boston, the more I feel like this city is a secret that we all share. I realize now that this is the definition of home. I can speak endlessly about the pros and cons of Boston, but I will always love it unconditionally. And when I visit another city or town, I'll fall in love with its charm or its unique architecture or its optimistic population, but I will ultimately say, "This place is wonderful, but I couldn't live here." A local will reply, "Well, you don't know the city as well as I do. You don't understand." And he'll be right. I won't.

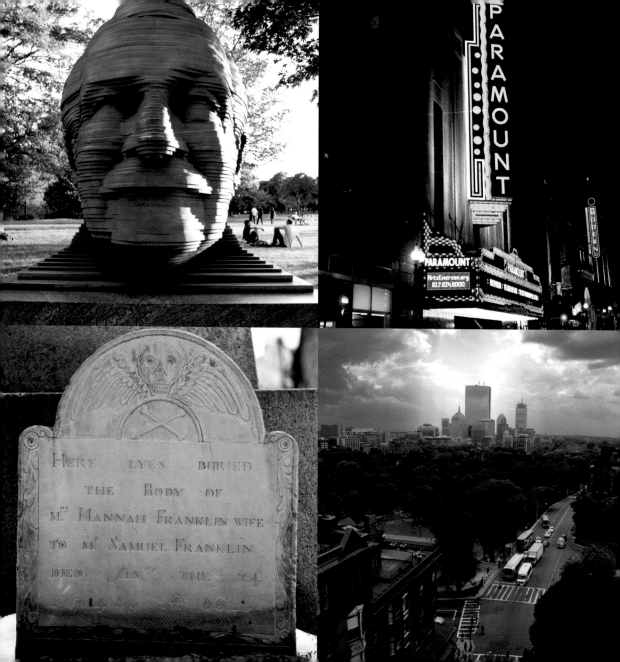

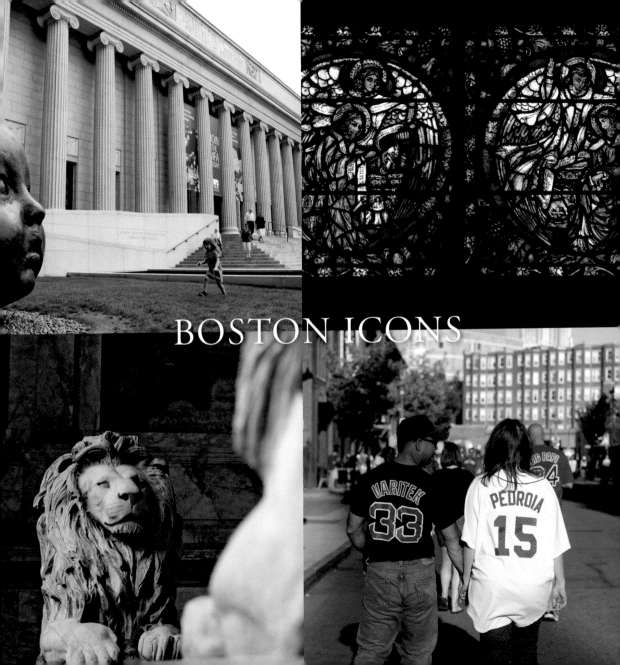

BOSTON ICONS

ARNOLD ARBORETUM

Alfred Nobel, the armaments producer and the inventor of dynamite, left behind a large portion of his fortune to fund the internationally renowned Nobel prizes. Cornelius Vanderbilt, the railroad tycoon, left behind Vanderbilt University and Grand Central Depot, the predecessor to Grand Central Station in New York City. Isabella Stewart Gardner and her husband John Lowell Gardner, the trader and businessman, put their fortune toward the Isabella Stewart Gardner Museum in Boston.

There is a long history of tycoons and magnates who funded or founded some of the public's greatest treasures. So it occurred with the Arnold Arboretum, a public space that all Bostonians know and love, although outsiders may not have heard of it.

James Arnold, a whaling merchant from New Bedford, left behind a portion of his fortune for "the promotion of Agricultural, or Horticultural improvements." Arnold died in 1868, and in 1872 the trustees of his will transferred his estate to Harvard University, so that it could be combined with the former

The oldest public arboretum in North America and one of the world's leading centers for the study of plants. This 265-acre landscape is open from sunrise to sunset every day of the year. For more information visit www.arboretum .harvard.edu.

Bussey estate to create the Arnold Arboretum, a total of 265 acres dedicated to horticulture and botany.

The arboretum has a unique 1,000-year lease with the City of Boston, signed in 1882, granting Harvard ownership and control but including the land in the city's park system. Thus, the arboretum has become a link in the Emerald Necklace, the 7-mile system of parks and parkways that Frederick Law Olmsted planned between 1878 and 1892 (other links in the necklace include Boston Common, the Back Bay Fens, and Jamaica Pond).

The park draws people from all over the city, especially from nearby Jamaica Plain and Roslindale—in the springtime you will find couples strolling, bicyclists, runners, and amateur botanists, while in the winter you'll see children sledding, showshoers, or local residents walking their dogs. While tourists may not recognize the name of the arboretum, you can walk up to any Bostonian in the street, and he or she will certainly recall a memory from this place.

BOSTON BAKED BEANS

If you've never visited Boston, you're in for a surprise. First of all, the streets are paved with beans. Some neighborhoods, such as Beacon Hill, prefer to use garbanzo beans for their sturdy, cobblestone effect. Brookline, on the other hand, uses lentils, meticulously mixed, poured, and dried. Neighborhoods in Cambridge along the river use hard-shelled black beans for their water resistance.

If you do visit, I hope you like beans, because restaurants in Boston don't serve anything else. Also, you should be warned: People in Boston don't purchase goods with dollars. Instead, they use beans. (Don't walk around flaunting your great northerns, because that's a sure way to attract pickpockets.)

None of this is true, of course. Boston is known as Beantown because of a Colonial-era predilection, but today baked beans are no more popular than Italian sausage or potato knishes—probably less. The popularity of Boston baked beans was so great, and its legend has persisted so powerfully, that the baked navy bean is even the Massachusetts state bean. Baked beans, however,

are actually a dish that the colonists learned from Native Americans.

Native Americans used to bake navy beans with bear fat and maple syrup. The colonists eventually adapted this method to incorporate pork and molasses. Other regions, such as Maine, used maple syrup, brown sugar, and other meats or fats, but Boston used molasses simply because of its abundance. In the triangle trade between the West Indies, West Africa, and North America, Boston became a major producer of rum, and the city (sometimes literally) overflowed with molasses (in 1919, a molasses tank in the North End burst, releasing over 2 million gallons of molasses into the street, killing 21 people and injuring 150).

Boston cuisine has evolved tremendously since the Colonial era, but it's comforting that the tradition of baked beans survives in the nickname Beantown. It's a reminder of eras past: Native Americans who used to cook beans in deer skins, colonists who ate leftover beans on the Sabbath, settlers and natives alike who led lives both more simple and more complex, more challenging in some ways and easier in others.

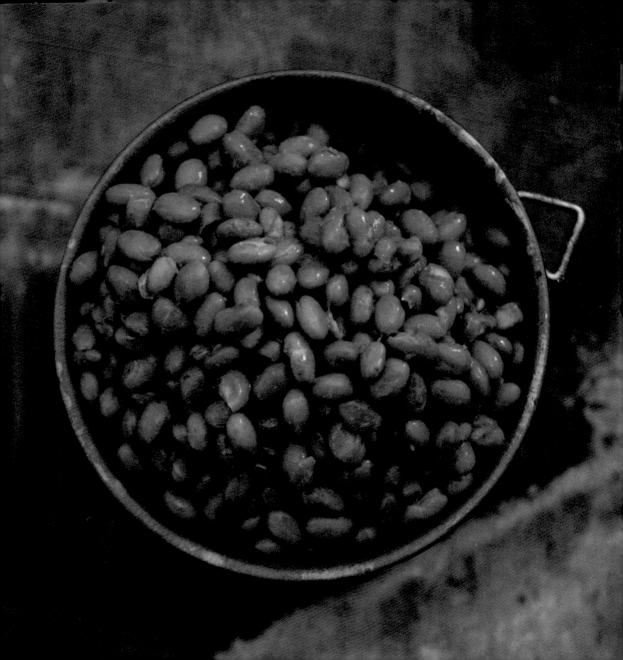

BOSTON COMMON

If Boston were a school (which is not so far from the truth, with its universities, museums, nonprofit organizations, biomedical industry, and think tanks), Boston Common would be the playground. Bought from William Blaxton by the Massachusetts Bay Colony, Boston Common was founded in 1634, making it the oldest public park in the United States.

The 50-acre park has not always been the playground of Boston, however. It has served as a cow pasture, a burial ground, a site for public hangings, and the stage for massive gatherings. The Minutemen gathered there during the Revolutionary War, as did the British redcoats, before they marched to the battle of Lexington and Concord in April, 1775. Martin Luther King Jr.

Boston Common is free and open to the public all day every day. To learn more about the oldest public park in the United States, visit www.cityof boston.gov /freedomtrail /bostoncommon .asp or call (617) 357-8300.

has spoken at the Common, as has Pope John Paul II.

The Common used to reflect the beliefs of the Puritan founders: It was illegal to kiss your wife or child in public on the Sabbath, for example. It is ironic, then, that the wavy pastures of the Common now host plenty of Sunday weddings, as well as a myriad of other events the Puritans would have scorned (they might have frowned upon the protests against the Vietnam war, for example).

Today the Boston Common marks the beginning of the Freedom Trail, the 2.5-mile, red-brick trail along some of Boston's most notable landmarks. It also stands at the head of the Emerald Necklace, the 9-park, 1,100-acre system of parks designed, in part, by Frederick Law Olmsted.

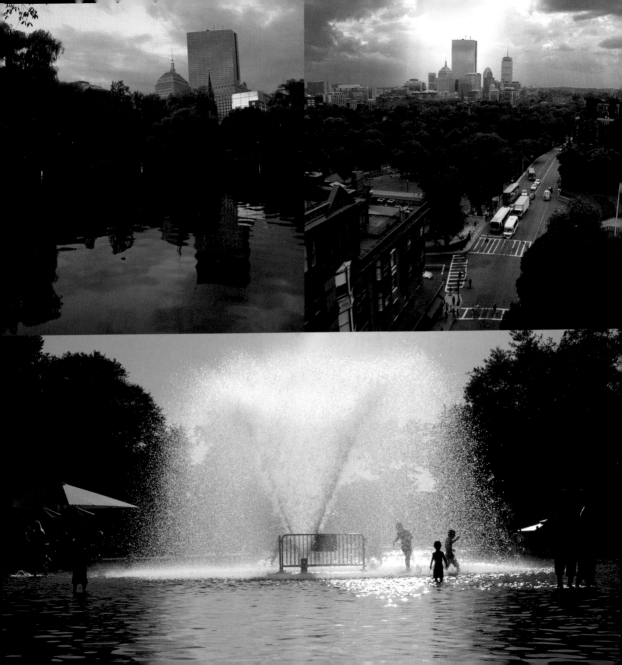

BOSTON GAS TANK

If you drive north into Boston along Interstate 93, you will pass, among other things, the University of Massachusetts, the John F. Kennedy Presidential Library and Museum, Castle Island and Pleasure Bay, and a 140-foot liquefied natural gas tank covered in bright, rainbow-colored swaths.

The tank, as known within Boston as the Red Sox are known without, became famous in 1971 when Corita Kent—peace activist, former nun, and artist (famous for the Love postage stamp)—received a commission from Boston Gas to paint the tank in the now-iconic purple, green, blue, orange, and yellow stripes. The tank became famous, however, not because of the unusually optimistic paint job for a natural gas tank, but because many locals believed they saw the likeness of Ho Chi Minh, former president of North Vietnam, in the blue stripe.

Originally, in fact, there were two tanks, and the original tank that Kent painted was demolished in 1992. Her design was copied onto the remaining

Located along Interstate 93 at Dorchester.

tank, but Kent, who died in 1986, never revealed whether she intended viewers to see Ho Chi Minh in her work. In 2001 Mike Conors, the spokesman for KeySpan Energy, which now owns the tank, said in an interview with NPR that the tank has become a "Rorschach test of whatever the popular psyche is at the time." People have seen fugitive Whitey Bulger, Saddam Hussein, Osama bin Laden, or even Fred Flintstone.

Whether or not the blue stripe contains hidden messages, Kent's original intent—a colorful, celebratory marker along Boston Harbor—has remained intact. It's slightly bizarre that two of Boston's most eye-catching icons, the Citgo sign and the Boston Gas tank, come from the energy industry, but it's an interesting result of icons that they eclipse associations of ownership. Yes, KeySpan owns the Boston Gas tank, but in the minds of Bostonians, we all do. Perhaps that is one of the essential definitions of an icon: something so controversial, beloved, or steadfast that it belongs to everyone, in spirit at least.

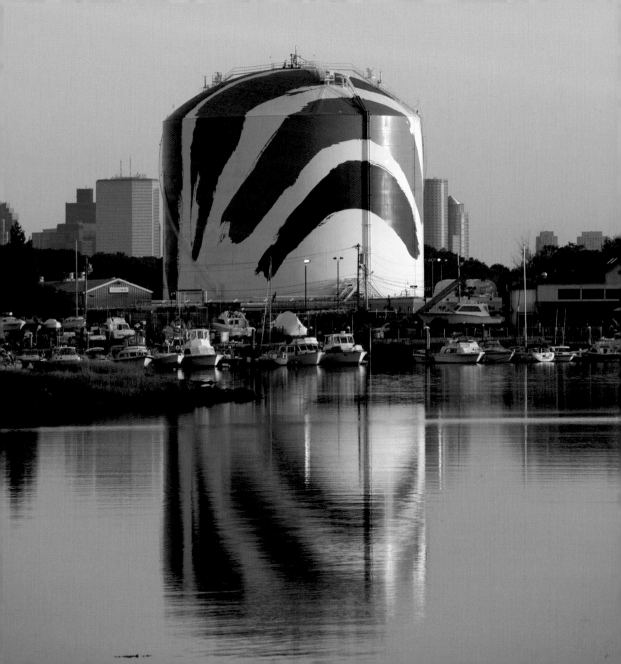

BOSTON HARBOR

The story of Boston Harbor is the story of settlement in the New World, the story of revolution, the story of human folly and subsequent remediation. Ever since John Smith landed in the region in 1614, Boston Harbor has served as a major port for New England trade. The port served as the heart of circulation between the northern colonies, England, and the rest of the world, including Africa. In 1773 it also witnessed the colonists' revolt against England, when they dumped 42 tons of tea into the harbor in protest of the Tea Act and taxation without representation.

In 1876 the harbor strained under the sewage load, and the state approved the Boston Main Drainage System, a system for channeling sewage to Moon Island, then releasing it with the outgoing tide. Nevertheless, this and other efforts still left the harbor contaminated. By the 1970s and 1980s, Boston Harbor had a reputation as the filthiest harbor in the country. This

Once considered the filthiest harbor in the United States, the harbor has since cleaned up its act. For information, events, walking tours, or sponsorship, visit The Boston Harbor Association at www.tbha.org.

reputation even entered the canon of pop music, with the 1966 song "Dirty Water" by the Standells (a song you will hear today if you attend a Red Sox game at Fenway Park).

Ultimately, the story of the harbor is one of recuperation and rejuvenation. In the mid-1980s Boston began sincere cleanup efforts, including a secondary treatment plant on Deer Island, the formation of the Massachusetts Water Resource Authority, and the formation of supportive organizations such as Save the Water/Save the Bay. The efforts have demonstrable results: the return of native fish species such as smelt, striped bass, and bluefish and the increased presence of porpoises and harbor seals.

For the nation the harbor's cleanup was a news story. For Bostonians it was catharsis. A harbor is the heart of a bay city, and a polluted harbor bears heavily on its inhabitants. As the estuary and bay become progressively cleaner, Bostonians seem to stand even taller.

BOSTON LATIN SCHOOL

Of the 56 signers of the Declaration of Independence, 5 were pupils at Boston Latin.

In a city of schools, Boston Latin is the first—the oldest existing school in America (a year older than Harvard) and the first public school. The Town of Boston founded the school on April 23, 1635, largely due to the efforts of the Reverend John Cotton, who, according to the school's history, "sought to create in the New World a school like the Free Grammar School of Boston, England, in which Latin and Greek were taught." The first schoolmaster, Philemon Pormort, held the first classes, consisting of fewer than 10 boys, in his home.

As the oldest school in the New World, Boston Latin boasts an impressive list of alumni: 5 signers of the Declaration of Independence (John Hancock, Samuel Adams, Benjamin Franklin, Robert Paine, William Hooper), 4 Massachusetts governors, and Louis Farrakhan—although Farrakhan and Franklin never graduated.

The school eventually received a permanent schoolhouse in 1645, a wooden structure on School Street that was taken down in 1745 for the expansion of King's Chapel; a statue of Benjamin Franklin now stands on this location, in front of the old city hall. The school also continued to educate only boys until Helen Magill White became the school's first female graduate in 1877. In the same year, however, Girls' Latin School was founded (now Boston Latin Academy), and Boston Latin didn't become coeducational until 1972.

Boston Latin remains one of the country's finest schools—a point of pride, as a public exam school (the exam today is a standard application process including standardized academic testing, but in the more Puritan year of 1734, students read verses from the Bible to apply). Now occupying a campus in the Fenway neighborhood of Boston, Boston Latin is arguably the first seed of Boston's reputation as a city of learning; it is certainly responsible for maintaining that reputation.

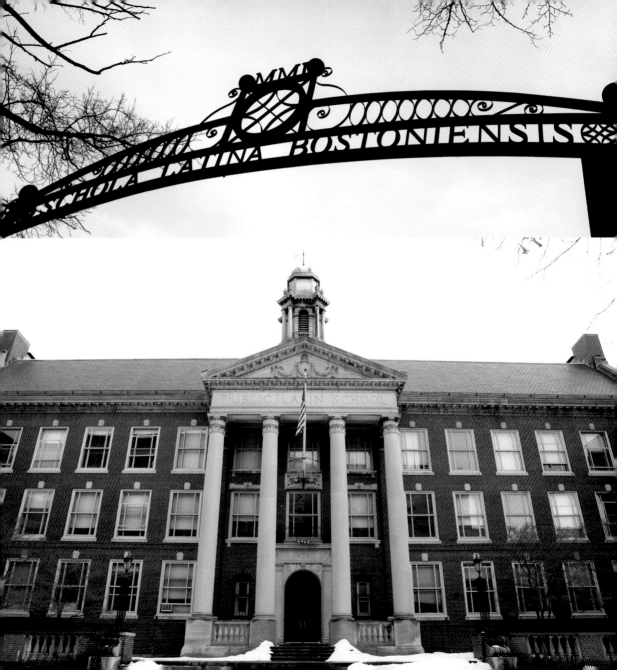

BOSTON PUBLIC LIBRARY

The public library in the United States derived from the private library. The private library derived from private collections. Doctors, clergy, or colleges kept private collections, which often reflected upon the owner's education and esteem. In the 18th century the concept of a social library evolved, such as Benjamin Franklin's Library Company of Philadelphia, a collection of books made available to its private members, who owned stock in the library.

The concept of circulation likely came from bookstores and print shops that rented books for a fee, and the final concept of a public library—free membership—likely followed the trend of publicly funded school libraries. Horace Mann, secretary of the Massachusetts Board of Education in the 1830s, encouraged the development of school libraries as an essential tool in the educational process.

These elements—membership, circulation, and free access—combined in 1854 with the opening of the Boston

Boston Public Library houses 6.1 million books, over 1.2 million of which are rare books and manuscripts, including first-edition folios of William Shakespeare's plays, original music from Mozart, and the personal library of John Adams. The Central Library in Copley Square serves as the headquarters for the Boston Public Library's 26 branch libraries.

Public Library, the country's first publicly supported free library (Peterborough, New Hampshire, founded a free public library in 1833, but as an accidental by-product of a failed college; thus Boston often receives the credit of precedence). In 1895 the library opened the McKim building, the stone building on Copley Square that still stands today. Charles Follen McKim designed the building, drawing inspiration from the Bibliothèque Sainte-Geneviève in Paris, the Tempio Malatestiano in Rimini, and the Palazzo della Cancelleria in Rome.

A modern extension stretches behind the McKim building, a postmodern design by Philip Johnson that opened in 1972. When the original library opened, before either the McKim or Johnson buildings existed, the library boasted 16,000 volumes. Today it houses nearly 21 million holdings of all media types and continues to serve as one of the nation's leading research and community libraries.

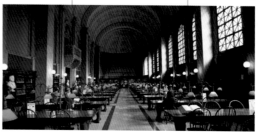

BUNKER HILL MONUMENT

When you stand facing the 221-foot obelisk commemorating the Battle of Bunker Hill, the first thing you will notice is that you are standing on Breed's Hill. The battle itself took place primarily on Breed's Hill but took the name of the more northerly Bunker Hill, since redcoats and Minutemen had both originally planned on occupying Bunker Hill.

This face-off between the British army and the Colonial army represented the first major stand-off of the Revolutionary War. The redcoats sent 3,000 soldiers to defeat 1,200 Colonial soldiers, but the colonials held off the British for their first two assaults. The colonists eventually retreated during the third assault, possibly due to a shortage of ammunition. It is the shortage of ammunition, in fact, that led to the famous order, "Don't fire until you see the whites of their eyes." In Boston lore this is attributed to Colonel William Prescott, one of the battle's heroes whose statue sits proudly beside the obelisk, but

Visit the Bunker Hill Monument free of charge at Monument Square in Charlestown. There are no elevators, but the 294-step journey is a small price to pay for the amazing vista at the end of the climb.

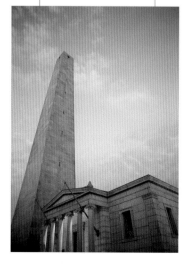

in truth, records give various possible sources for this order—if it was said at all.

The British occupied Breed's Hill and reported the battle as a victory, but they suffered heavy losses: 1,050 casualties compared to 450 for the colonists. After the battle General Nathanael Greene of the colonies wrote, "I wish I could sell them another hill at the same price." This Pyrrhic victory for the colonies sent many ripples through the political climate of the time: It was a message of confidence for the colonists resisting the British; it was a message of warning to King George; and it was a testament to the will and determination of the nascent American people.

Daniel Webster expressed this sentiment in 1843 at the opening of the newly completed obelisk: "And, by the blessing of God, may that country itself become a vast and splendid monument, not of oppression and terror, but of Wisdom, of Peace, and of Liberty, upon which the world may gaze with admiration for ever!"

CHARLES RIVER

This is the image: predawn haze, curls of fog making slow pirouettes over the placid surface of the Charles, the Harvard crew team darting quickly—almost silently—under a footbridge, leaving perfect ripples in their wake.

It is the predominant impression of the Charles River, its low banks filled with sunbathers and the esteemed universities that sprout on either side of its meandering route. And it is an accurate image, but not the only image. Going backward in time, here is the flip-book of the Charles River: Governor Bill Weld jumping into the river in 1996 to prove his commitment to cleaning the waterway (despite its state of pollution at the time); a rower falling into the river and receiving a tetanus shot afterward; a river choked with sewage, pollutants, and runoff in the mid-20th century; the creation of the Esplanade in the 1930s; the damming

The Department of Conservation and Recreation's Charles River Reservation is a linear park that stretches from Boston Harbor up the river for 20 miles. For more information, visit www.mass .gov/dcr/parks /charlesRiver/.

of the river's mouth in 1910; the creation of the Boston-Cambridge basin in the 1890s; the digging of Mother Brook in the mid-17th century; the renaming of the Massachusetts River to the Charles River; the "discovery" and naming of the Massachusetts River by John Smith; the Wampanoag tribes, paddling along the river before European settlers ever arrived.

Currently, the image of the Charles River includes the toothed Boston skyline, industry, recreation, bridges like

braces connecting the banks of Boston and Cambridge (or Watertown and Brighton, or Waltham and Newton). If you go back far enough in the flip-book of Charles River history, the image of the Charles River is quite simple: a relatively slow, meandering river, tree-lined and fecund, running its informal marathon from Hopkinton to the Atlantic Ocean.

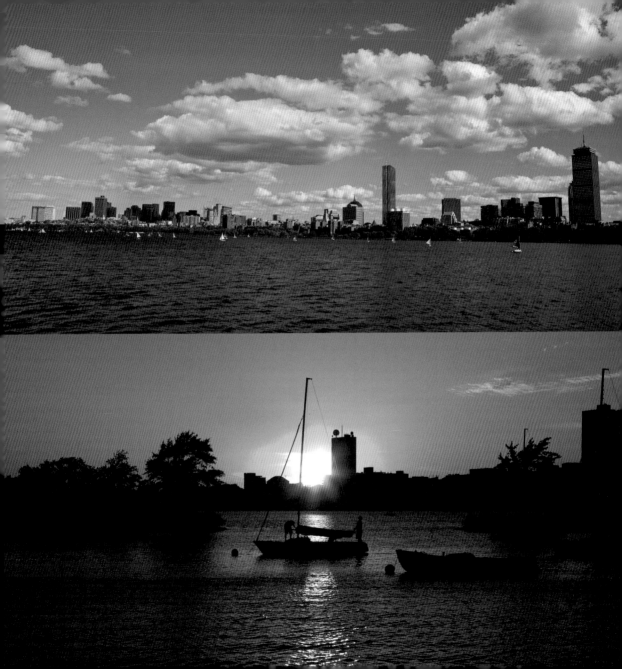

CHEERS

The Cheers bar in Boston would not be famous if it weren't for the 1980s television sitcom of the same name—in fact, the Cheers bar would not even be called the Cheers bar. Founded in 1969 as the Bull and Finch Pub, the bar was used as an inspiration for the television show. Since the show used exterior shots of the Hampshire House and the entrance to the Bull and Finch in its B roll and opening credits, new visitors to the Bull and Finch would enter the pub expecting the *Cheers* set they saw on television. Yet the layout of the Bull and Finch was quite different—although the details were the same: the Indian by the entrance, the chairs and tables, the taps and glassware. In 2002 the Bull and Finch officially changed its name to Cheers, since it had become a mecca for fans of the show anyway.

The television show, produced by Charles and Burrows, the sitcom juggernauts behind the *Mary Tyler Moore*

To find out more visit www.cheers boston.com.

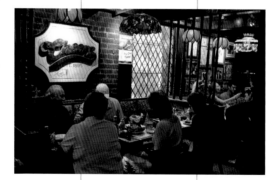

Show, the *Bob Newhart Show*, and *Taxi*, lasted 11 years and 275 episodes. It earned 100 nominations for Emmy awards and made household names of cast members Ted Danson, Rhea Perlman, Kelsey Grammer, Woody Harrelson, Kirstie Alley, Shelley Long, Bebe Neuwirth, George Wendt, and John Ratzenberger.

Cheers also made household names of its characters. The show's theme song wistfully croons that "sometimes you want to go where everybody knows your name." This is, ultimately, the great success of *Cheers*: that after 11 years on the air everybody did want that neighborhood bar where the dysfunction of life didn't matter as much because everyone belonged. And when visitors make pilgrimages to the old Bull and Finch Pub, this is what they are looking for—the same feeling they experienced while watching the show, that brief comfort of finding your home.

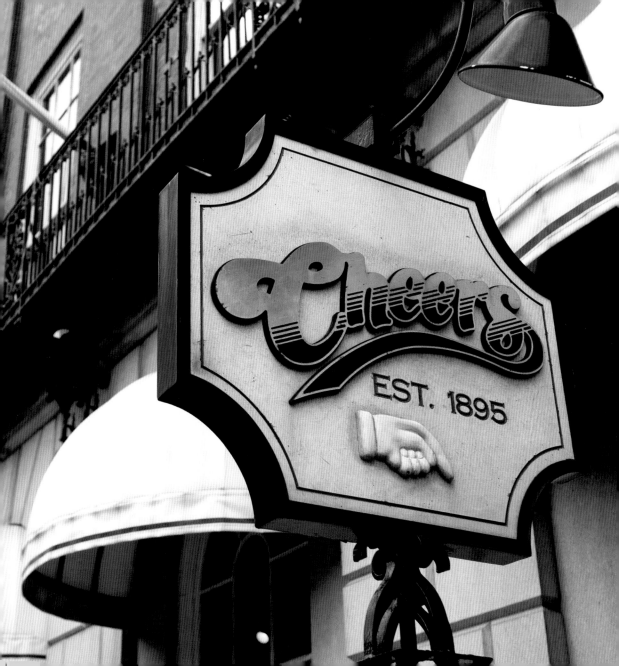

CHINATOWN

Like the North End, China-
town's timeline chronicles not just
Chinese immigrants to Boston, but all
immigrants to Boston: Irish, Italian,
German, Vietnamese. Some of today's
Chinatown—a downtown neighborhood
along Beach Street, near the Common—
sits on land created from filling in tidal
flats. Railway developments eventually
made this area less desirable and conse-
quently attracted waves of immigrants.

The first Chinese immigrants
began arriving in Boston in the 1880s,
even pitching tents
in today's Ping On
Alley. While other
immigrant waves
have diffused out
of the area, China-
town is still about
70 percent Asian in
population, though
not just Chinese; like
New York's China-
town the area also
hosts a large Viet-
namese population,
evidenced by the Vietnamese sandwich
or pho shops that sprout up.

*Every summer
a vacant lot
near Boston's
Chinatown Gate
is transformed
into a free
outdoor theater
featuring kung
fu and classic
Chinese-language
films under the
Boston stars.
Learn more at
www.filmsat
thegate.org.*

The area has become mixed in
many senses: Housing, once dominated
by low-level inexpensive buildings, now
includes new residential towers and
chic renovations of older buildings;
some shops sell herbs and medicines
out of wooden drawers, while others sell
DVDs and mobile-phone plans. And
some of the first-generation immigrants
will gather in the park to play xiangqi
or mah-jongg, while second- or third-
generation Americans will play on their
iPhones.

The paifang gate
at the entrance to
Chinatown on Beach
Street and Surface
Road nicely charac-
terizes the spirit of
the neighborhood. A
gift from the city of
Taipei, it welcomes
guests who are visit-
ing the unique mix
of cultures as well
as new immigrants
who are still arriv-
ing, looking for a foothold in their new
home.

ASIAN GARDEN

香滿園

40¢

西洋菜

$1⁰⁹ EA 札

天天茶市
晚飯宵夜
游水海鮮
即叫

CHRISTIAN SCIENCE PLAZA

The story of the Christian Science Plaza is, foremost, the story of Mary Baker Eddy, a dedicated author and teacher and the founder of Christian Science. Born in 1821 as Mary Baker, Eddy refers to an event in 1866 as the moment she discovered Christian Science: She had been ill off and on throughout her life, and in 1866 she had also undergone a series of personal losses. She had been studying healing practices all her life, most recently with Phineas Quimby in Portland, Maine. In 1866 Eddy was bedridden in critical condition, but upon reading about Jesus's healing in the Bible, she became well.

Eddy's philosophy combined holistic healing methods with Christian faith, which she set out in *Science and Health*, published in 1875. One of its tenets was that Jesus's healing could be understood scientifically—that it was natural and reproducible. Since existing Christian churches did not acknowledge Eddy's phi-

Christian Science Plaza is located east of Massachusetts Avenue and north of Huntington Avenue. To learn more visit http://christianscience.com/church/the-mother-church/boston-activities/plaza/.

losophy, Eddy eventually started her own, the Church of Christ, Scientist. (Before her death in 1910, Eddy also launched the *Christian Science Monitor*, now one of the world's most respected newspapers.)

The Mother Church, a grand stone building facing Huntington Avenue in Back Bay, was designed in the 1960s and completed in the 1970s. It is one part of the larger Christian Science Plaza, mostly known for the church, reflecting pool, and fountain, as well as the Mapparium, a 3-story stained glass globe located in the Mary Baker Eddy Library.

With the Prudential towering behind it, the Christian Science Plaza is, if nothing else, a beautiful sight. But it is also a testament to the extraordinary will and faith of one woman. You don't have to subscribe to Christian Science or any religion to appreciate how one person's conviction built an empire.

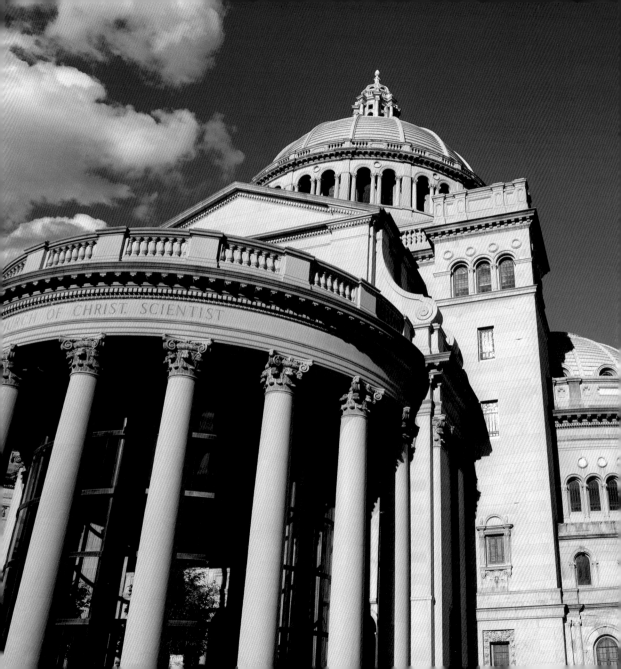

CITGO SIGN

The Citgo sign began, like most other signs, as an advertisement—namely, an advertisement for the Cities Service gas and electric utility, and the 60-square-foot sign sat atop the company's Beacon Street offices starting in 1940. At the time the sign portrayed Cities Service's trefoil logo, but in 1965 the sign changed to the familiar "trimark" Citgo logo, which was the icon for the company's refining and marketing division.

In 1979 Governor Edward King decided to shut down the sign as an example of energy conservation, and 4 years later Citgo endeavored to deconstruct the sign. Bostonians, however, protested. The city's Landmarks Commission postponed the disassembly, never granting it landmark status but nevertheless inspiring Citgo to rebuild the sign in 1983.

Until 2005 the sign consisted of up to 5,878

Measuring 60 feet by 60 feet, the Citgo sign atop the Boston University bookstore at 660 Beacon Street is so famous that Citgo includes a history of the sign on its website at www.citgo.com /AboutCITGO /BostonSign.jsp.

glass tubes for neon lighting—which, end to end, added up to a length of more than 5 miles. Currently, it employs 218,000 LED lights and runs from dusk until midnight.

Usually, neighborhoods protest the construction of billboards—or at best, tolerate them. The Citgo sign, however, has risen above its original purpose. Few Bostonians raise their eyes to the Citgo sign and think of the oil refining company. Instead, they think of home runs at Fenway Park, the skyline viewed from Cambridge, the reassuring glow when leaving the Kenmore Square station on the green line at the end of a long day in winter. It is a beacon, a modern-day lighthouse: When flying into the city, taking the low approach over the harbor, you will see the illuminated square of the Citgo sign peeking through the skyscrapers, and you will know that you are home.

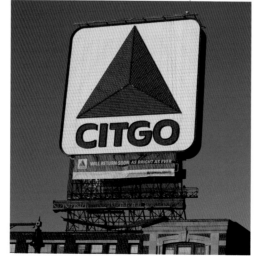

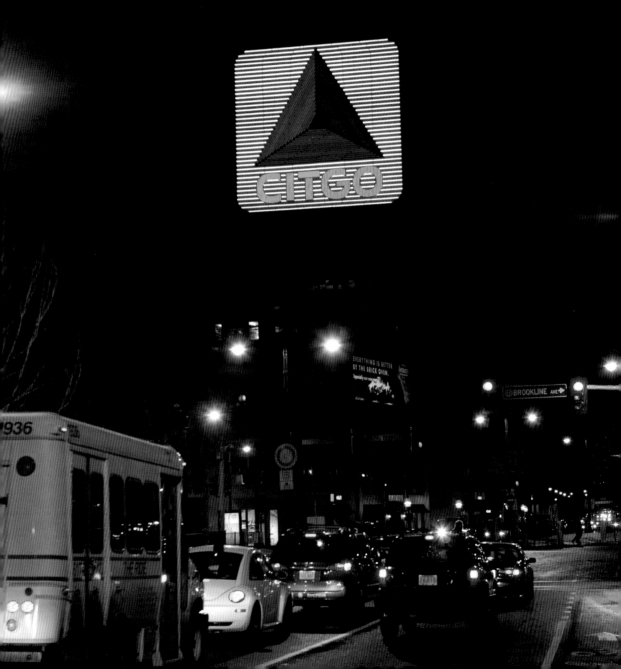

CLAM CHOWDER

Some foods, such as lobster, evolve in their culinary esteem; formerly a peasant food, lobster has become expensive, coveted fare. Clam chowder, similarly, has modest beginnings but unlike lobster has remained inexpensive and modest, while simultaneously becoming more popular and ubiquitous.

Fishermen likely created the original chowders: thick soups with salted pork fat, crumbled biscuits, milk, and the offal from their daily catches. The word chowder itself likely comes from the Latin *calderia*, which spawned the French words for "hot" and "cauldron." Thus the definition of clam chowder simplifies to a hot soup in a pot.

Boston, as one of the primary seaports in New England, sometimes receives credit for New England clam chowder, but the dish is a regional creation, with several local flairs. Rhode Island chowder uses a clear broth and cod instead of clams; Boston chowder is thick and creamy, with clams and potatoes; Maine chowder sometimes uses tomatoes. (Maine residents, incidentally, will call their chowder "Down

East chowder," despite Maine's being the northernmost state in New England; the state is, however, downwind for sailors, and the farthest East—thus the name.)

A food can become an emblem of a culture or place, and in the process it can lose its working-class appeal, like the steak and cheese in Philadelphia, which has become a tourist food more than a local one. Chowder, however, has managed to retain both identities: a cultural symbol of Boston and a comfort food for Bostonians of all ranks and professions. Novelist Herman Melville even took the time to describe the experience when he sampled the chowder at Nantucket's Try Pots chowder house:

> However, a warm savory steam from the kitchen served to belie the apparently cheerless prospect before us . . . Oh, sweet friends! hearken to me. It was made of small juicy clams, scarcely bigger than hazel nuts, mixed with pounded ship biscuit, and salted pork cut up into little flakes; the whole enriched with butter, and plentifully seasoned with pepper and salt . . . the chowder being surpassingly excellent, we despatched it with great expedition.

COPP'S HILL BURYING GROUND

While King's Chapel and the Granary Burial Ground mark the resting places of Paul Revere, Samuel Adams, John Winthrop, and many other celebrities of Boston's history, Copp's Hill Burying Ground has a reputation in Boston as the working man's graveyard. The burial ground does contain some well-known figures, such as William Copp, the shoemaker and settler; Robert Newman, who hung the two lanterns from the Old North Church to warn patriots in Charlestown that the British were coming by sea; and Prince Hall, abolitionist and founder of Black Freemasonry.

Over 10,000 people are interred at Copp's Hill, and a large percentage of them were artisans who lived and worked in the North End. The original grounds were established in 1659, making Copp's Hill (originally North Burying Ground)

The burial ground is located on Hull Street and is open daily from 9 a.m. to 5 p.m. For more information visit www.the freedomtrail.org /visitor/copp-hill .html or call (617) 635-4505.

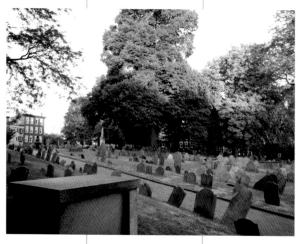

the second burial ground established in Boston.

One of the most noticeable features of Copp's Hill Burying Ground is the curiously tall, red-brick walls surrounding it, especially on the side of Snow Hill Street, where the wall towers over passersby. The original cemetery stood at ground level, but in the early 19th century, land was moved from Copp's Hill to fill Mill Pond, reducing the height of the hill by about 7 feet on average, but the burial ground remained intact. This is one reason that visitors to the grounds come for the historical intrigue, but also for the view: Copp's Hill looks out over the harbor, the Zakim Bridge, the Charles River, the USS *Constitution,* the Old North Church, and the Bunker Hill Monument.

EMERALD NECKLACE

What would North America look like without Frederick Law Olmsted? Olmsted, who lived between 1822 and 1903, was considered one of the first American landscape architects—which is apparent, because he seemingly designed every public space in North America: New York's Central Park, Prospect Park, Riverside Drive, Riverside Park, and Grand Army Plaza; Montreal's Mount Royal Park; Belle Isle Park in Detroit; campuses such as those at the University of Chicago and Yale University. Olmsted's vision of green cities quite literally shaped the modern urban landscape.

Olmsted left his stamp on Boston with the Emerald Necklace, the 1,100-acre system of parks that begins near Downtown Crossing and ends with the Arnold Arboretum. It stretches through Boston, Brookline, Roslindale, Roxbury, and Dorchester and includes 9 "links" in the chain: Boston Common, the Public Garden, Back Bay Fens, Arnold Arboretum, Commonwealth Avenue Mall, the Riverway, Olmsted Park, Franklin Park, and Jamaica Pond.

In 1870 Olmsted gave a speech in Cambridge proposing the Emerald

For more information on the Emerald Necklace Conservancy, visit www.emerald necklace.org.

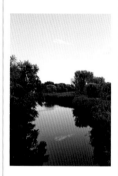

Necklace: "We want a ground to which people may easily go after their day's work is done, and where they may stroll for an hour, seeing, hearing and feeling nothing of the bustle and jar of the streets, where they shall, in effect, find the city put far away from them." Boston Common, the Public Garden, and the Commonwealth Avenue Mall already existed, but by the turn of the century, Olmsted had completed his vision.

The park exists today as a collaboration between many organizations: the Emerald Necklace Conservancy, the Commonwealth of Massachusetts, the City of Boston, the Town of Brookline, and Harvard University, among others. Conservation efforts, of course, have continued past Olmsted's initial work. The conservancy, for example, is currently working on its Muddy River Restoration Project, to rehabilitate the Muddy River and solve issues with flooding. But without Olmsted's initiation would Boston have so much green space? Possibly, but the city is certainly greener, and happier, because of his foresight and force of will.

ESPLANADE

The Charles River Basin, the wide, level expanse of river between Boston and Cambridge, only came into existence recently, relative to the life span of a river. In the 19th century the river originally fanned out into a broad stretch of tidal wetlands. Governor William E. Russell appointed Owen A. Galvin as head of the Charles River Improvement Commission in 1891, thus beginning the process of landfill and damming that would create the Charles River Basin, the Esplanade, and other significant portions of Boston's landscape, such as the Back Bay neighborhood.

The Esplanade itself resulted from a $1 million gift from philanthropist Helen Storrow, who gave the money to build a park with the one condition that a road never run through it. She also donated the funds for a community boating house in 1941, the same year that the Edward Hatch Memorial Shell, or Hatch Shell, opened to the public. (Ironically, after Storrow died in 1949, the state built a thoroughfare between the Esplanade and Back Bay, naming it Storrow Drive.)

Sandwiched between the Charles River and Storrow Drive, the Esplanade is a popular Boston attraction for both visitors and residents. Six miles of paths and the oldest public boat club in the United States are only a couple of the incredible features of the Esplanade.

The Esplanade stretches for 3 miles along the Charles River, from the Museum of Science to the Boston University Bridge, and contains playgrounds, soccer fields, boathouses, and, of course, nearly 2,000 trees. The Hatch Shell hosts events such as Earth Day, summer outdoor movies, and, most importantly, the annual 4th of July concert by the Boston Pops Orchestra. (The Boston Pops, made famous by its former 50-year conductor Arthur Fiedler, serves as an alter ego to the Boston Symphony Orchestra, performing lighter classical and popular music. John Williams succeeded Fiedler, and Keith Lockhart currently conducts the group.)

But the park is more than the sum of its wading pools and bicycle paths. Almost every Bostonian has a memory of the Esplanade: Little League games, learning to sail, falling in love on the dock at sunset, the fireworks on the 4th of July, or simply driving by on Storrow Drive, observing the scenery. In that sense the Esplanade is more than a park—it is more like a memory or a friend, a part of us.

FANEUIL HALL

Some may know Faneuil Hall as the Cradle of Liberty—the site where Samuel Adams made his famous Revolutionary speeches (his statue stands prominently behind the hall, toward Government Center) and where the Sons of Liberty met to oppose the Sugar Act of 1763 or the Stamp Act of 1765. Others may know Faneuil Hall as the first centralized marketplace in Boston. The point is that everyone knows Faneuil Hall—which is funny, because the Town of Boston didn't really want it.

The story begins with Andrew Faneuil, a shipping magnate who bequeathed his fortune to his nephew Benjamin on the one condition that Benjamin never marry—a condition that Benjamin flouted. Consequently, Andrew's fortune went to Benjamin's brother, Peter, who remained loyal to Andrew's wishes and never married.

Peter used his newfound wealth to become one of Boston's richest and most active bachelors—but he was also a keen merchant and quite a generous public benefactor. It was Peter Faneuil who offered to build a town hall and marketplace for Boston and to donate it to the public trust. A Boston town hall meeting voted 367 to 360 to allow the hall's construction—a margin of only 7 votes.

This Boston treasure features historical sites, shops, over 40 eateries, and world-famous performers, including jugglers, clowns, magicians, and musicians. Seasonal events include the annual Harborfest, 4th of July Celebration, Street Performer Festival, and Tree Lighting Ceremony. Learn more at www.faneuilhall marketplace.com.

Thus Faneuil Hall came into existence, completed in 1742 from Red Medford brick and imported English glass, with a marketplace on the ground floor and the meeting hall above—a meeting hall hallowed by some of the country's greatest visionaries, where Samuel Adams denounced taxation without representation, where Susan B. Anthony argued for women's rights, where William Lloyd Garrison and Frederick Douglass spoke together, and where John F. Kennedy gave his final preelection speech in 1960.

Despite voting so narrowly for the hall's construction, Bostonians soon grew to cherish the hall—so much, in fact, that when it burned down in 1761, the town agreed to rebuild it. Faneuil Hall has gone through several slumps and restorations, and the current site—larger than the original—serves primarily the same purposes as outlined by Peter Faneuil: to house merchants and their buyers and to serve as a meeting-house for the people of Boston.

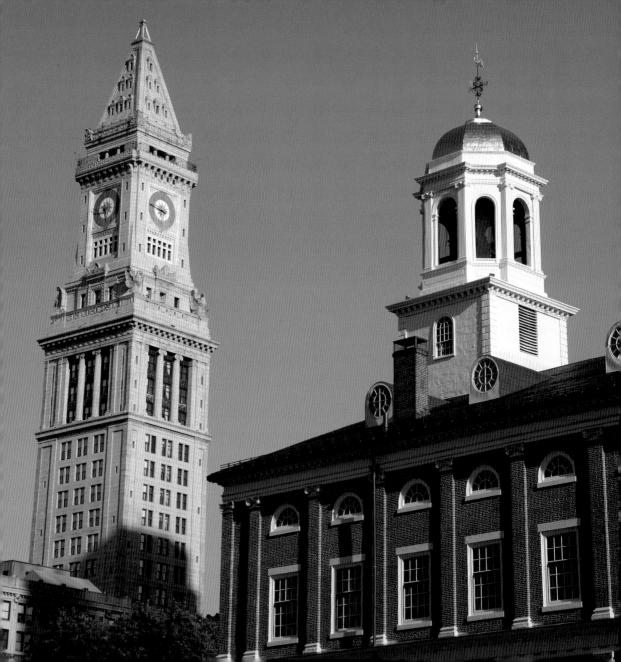

FIRST NIGHT

First Night is actually the last night, to be accurate. It is Boston's New Year's Eve celebration; thus it takes place on December 31, the last night of the year. "New Year's Eve celebration," however, does not come close to describing the experience.

Begun in 1976 by a group of artists, First Night initially was an artistic (and alcohol-free) event to celebrate the passing of the old year into the new one. Since then, First Night Boston has grown into a citywide and nationwide cultural event. According to First Night, Inc., the nonprofit that runs the event, it now attracts over 1 million visitors, with over 200 exhibits and performances, and it has spawned more than 200 similar First Night celebrations worldwide.

On the day of New Year's Eve, theaters, churches, and museums open

This cherished Boston tradition is produced by First Night, Inc., a private nonprofit organization. The organization's mission statement is "to reveal and celebrate diversity through the First Night celebration and the First Night Neighborhood Network, using art as a catalyst to unify the community through creativity, imagination and participation" (www.firstnight .org).

their doors for special events and performances; there is live music on the Common, as well as a series of ornate ice sculptures; and in the evening, the Grand Procession marches from the Prudential to the Common: an almost ragtag collection of stilt-walkers, giant marionettes, Chinese dragons, art cars, marching bands, and costumed revelers. Fireworks mark the end of the Grand Procession, and First Night events continue through the night.

These are still just numbers and descriptions, however. The magic of First Night is the spirit of camaraderie that overtakes the city. Families meet on the Common to view the ice sculptures; venues open their doors to the public; and the entire city seems to be out and about, exploring the First Night events, celebrating, happy to be together.

GRANARY BURIAL GROUND

It may sound slightly morbid that a large number of Boston's most iconic sites are graveyards. In practice, however, they serve as a celebration of Boston's most famous residents, as well as some of the forgotten ones. The Granary Burial Ground alone houses 2,345 gravestones (and possibly as many as 5,000 to 8,000 people), including those of Paul Revere, Samuel Adams, John Hancock, Robert Treat Paine, Peter Faneuil, James Otis, the 5 victims of the Boston Massacre, and Josiah and Abiah Folger Franklin, the parents of Benjamin Franklin.

The Granary Burial Ground was founded in 1660 to alleviate overcrowding in the adjacent King's Chapel Burial Ground, but the site didn't earn its current name until 1737, when a granary was built at the corner of Tremont and Park Streets, where the Park Street Church now stands. The gravestones themselves stand as markers of the era in which the cemetery was built: They commonly

Located on Tremont Street between Park and School Streets, Granary Burial Ground is the third oldest burying ground in Boston proper. Tours are given by the Freedom Trail Foundation. For more information check out www.cityofboston .gov/freedomtrail /granary.asp.

depict the Soul Effigy, a winged skull, or the Grim Reaper or Father Time. These are remarkable because the Puritans did not believe in religious iconography, so their expression of beliefs regarding the afterlife came in the form of tombstones.

The cemetery's famous residents receive much of the attention from tourists and visitors—the humble original slate marker for Paul Revere, the monuments in the two front corners for Samuel Adams and James Otis—but the unknown residents deserve recognition as well. There are the Infant's Tomb #203, where about 500 children were laid to rest; the stones whose markings have eroded with time; and the markers for lives we have since forgotten, such as Officer John Hurd of the Continental Army. All these lives deserve a thought from passersby, not simply because they are there, but because they are as responsible for building the United States as the Paul Reveres and John Hancocks.

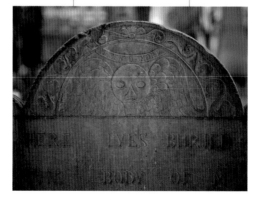

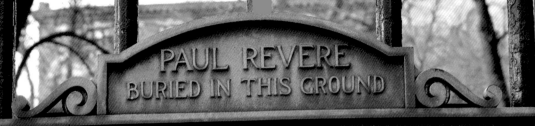

PAUL REVERE
BURIED IN THIS GROUND

This tablet as a memorial to Paul Revere
is erected by the
Paul Revere Memorial Association to
commemorate the opening to the public
on April 19, 1908
of his old house at No. 19 North Square
in this city.
May the youth of today when they visit
this old house be inspired with the
patriotism of Paul Revere

HARVARD UNIVERSITY

Harvard: only 7 letters, but such a large word. With over 10,000 undergraduate and graduate students; hundreds of acres of campus and property in Cambridge and Boston, including the 210-acre main campus at Harvard Square; and 12 degree-granting schools, Harvard is, purely physically, large. But the word "Harvard" looms even larger than its physical grounds. The university has become internationally renowned; a center for education, research, and culture; the ideal for ambitious high school students and academics alike.

Founded in 1636 by the Great and General Court of the Massachusetts Bay Colony, Harvard took its name from its first benefactor, the minister John Harvard from Charlestown, who died in 1638 and bequeathed half his estate, about 780 pounds, and his library of 400 volumes. John Harvard's statue, which sits next to University Hall in Harvard Yard, is one of the most photographed and visited symbols of the school.

Students, however, call the effigy of John Harvard "the statue of three lies." Its inscription bears the words, "John Harvard, Founder, 1638." Yet John Har-

For more information about Harvard, visit www .harvard.edu/.

vard did not found the college—he simply contributed; the school was founded in 1636, not 1638, which is the year Harvard died; and the statue does not depict John Harvard. Sculptor Daniel Chester French created the statue after Harvard's death, without a likeness of him for reference. The statue resembles a student that French used as a model.

It is easier to tell anecdotes about Harvard's history—the statue of three lies or how the school newspaper, the *Magenta*, changed its name to the *Crimson* on the day the school changed its official color—because its accomplishments are too many to list: the 8 U.S. presidents who graduated; its association with 75 Nobel Laureates; its equally prestigious Radcliffe College for women, with which it formally merged in 1999; and the myriad books, inventions, discoveries, and theories that have formed under its roofs. It is also difficult to describe only Harvard as an icon of Boston, when it is the network of universities and colleges—Boston University, Brandeis, Tufts, MIT, Boston College, Northeastern—that gives Boston its high density of students, academics, and research facilities.

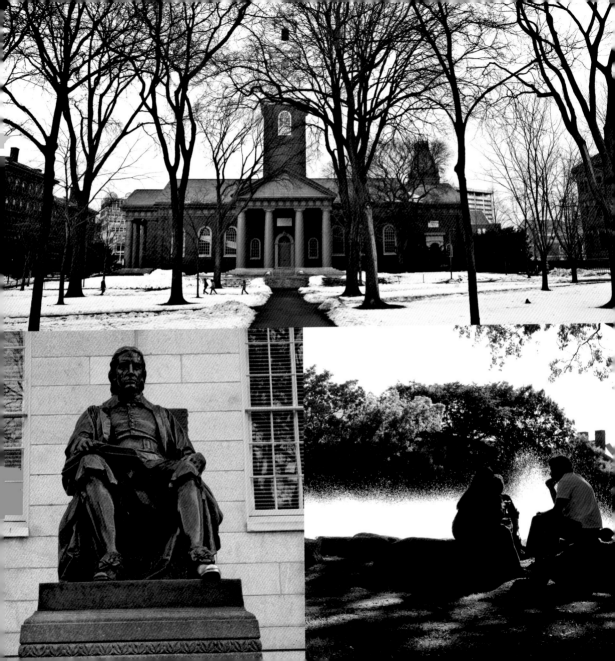

ISABELLA STEWART GARDNER MUSEUM

First, there is the woman herself, Isabella Stewart Gardner; second, there is the museum she built, one of Boston's finest; and third, there is the theft of 1990. The first two aspects of the museum make it iconic, but all three together have made the museum legendary.

Isabella Stewart Gardner is remembered as an unconventional socialite and philanthropist. Born in 1840 in New York City, she moved to Boston when she married John Lowell Gardner in 1860. From a young age she provided a wealth of gossip for the social pages of the newspaper. For example, Isabella's mother had a second child, a son, when she was in her late 40s; the papers speculated that this was Isabella's premarital child with John.

After John died in 1898, Isabella built an art museum, intended to resemble a palatial home, to house her

Located at 280 Fenway; www.gardner museum.org.

significant art collection. She designed it after the Palazzo Barbaro in Venice and completed the museum in 1903. Because of her strong collection of art, her relationships with prominent artists such as John Singer Sargent and James McNeill Whistler, and her social standing, the museum quickly became a cornerstone of the arts in Boston.

In 1990 thieves dressed as policemen entered the museum, handcuffed the security guards on duty, and stole several works worth hundreds of millions of dollars, including works by Degas, Manet, and Vermeer. The FBI lists the theft as one of the top 10 art crimes in history, and the case remains unsolved. Even without *A Concert* or *A Lady and Gentleman in Black*, however, the museum remains a pillar of the art world in Boston and a tribute to one of the city's quirkier philanthropists.

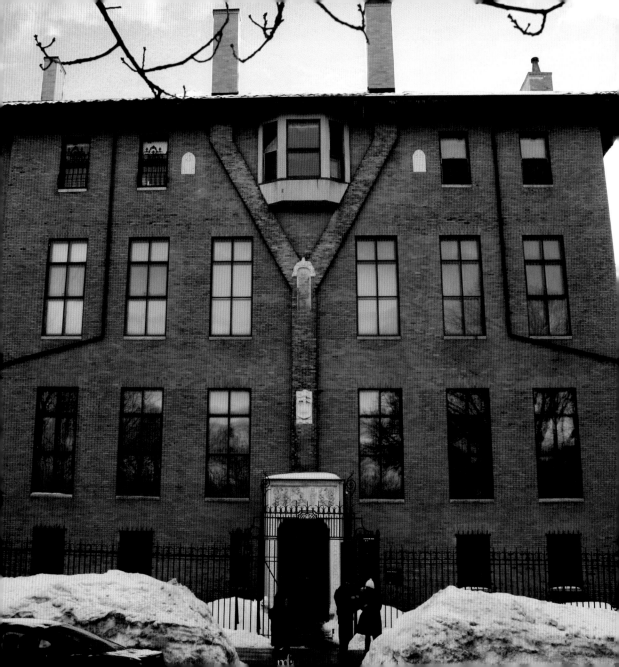

JFK BIRTHPLACE AND LIBRARY

In the 1960 presidential election, John Fitzgerald Kennedy received 49.7 percent of the popular vote, while Richard Milhous Nixon received 49.5 percent. In the electoral college, however, Kennedy won 303 votes to Nixon's 219, making him the 35th president of the United States of America. It is important to note the close race of 1960, because Kennedy's assassination and the continued legacy of the Kennedy family would raise Jack Kennedy, as he was known, to the status of martyr and political icon.

Jack Kennedy was born in Boston—in Brookline, specifically, at 83 Beals Street. His parents, Joseph Kennedy and Rose Fitzgerald, were also born in Boston, both to political families. The momentum and ambition of Joseph and Rose Kennedy created a political and cultural dynasty that has affected everyone in the nation. Their children, Joseph, John, Rose, Kathleen, Eunice, Patricia, Robert, Jean, and Edward, have all been celebrated, lambasted, and lamented due to an uncanny combination of success, tragedy, and infamy.

The JFK Presidential Library and Museum, at Columbia Point in Boston

The John F. Kennedy Presidential Library and Museum is located on a 10-acre park that overlooks both the sea and the city. It is one of 13 presidential libraries administered by the National Archives and Records Administration. Discover more at www.jfklibrary .org/.

Harbor, as well as the house on Beals Street, focus, of course, on the success and ideals of the Kennedy family. The family eventually moved from the house on Beals Street where Jack was born and away from Boston altogether, but Rose returned in 1967 to restore the house to its 1917 appearance as a memorial to Jack. While it does house some of the original belongings that Rose had saved, the birthplace serves more as Rose's memory of how things might have been.

That is one of the roles the Kennedy family plays in the public imagination: an icon of ideals, of what could be. The tragedies the Kennedys have suffered greatly overshadow their missteps in the hearts of many Americans. We will all remember—more than JFK's affair with Marilyn Monroe or the Bay of Pigs—the words of a young Catholic president at his inaugural speech in 1960: "And so, my fellow Americans: Ask not what your country can do for you—ask what you can do for your country." It is these words, more than any political success or scandal, that embody what the Kennedys could be—what we all could be.

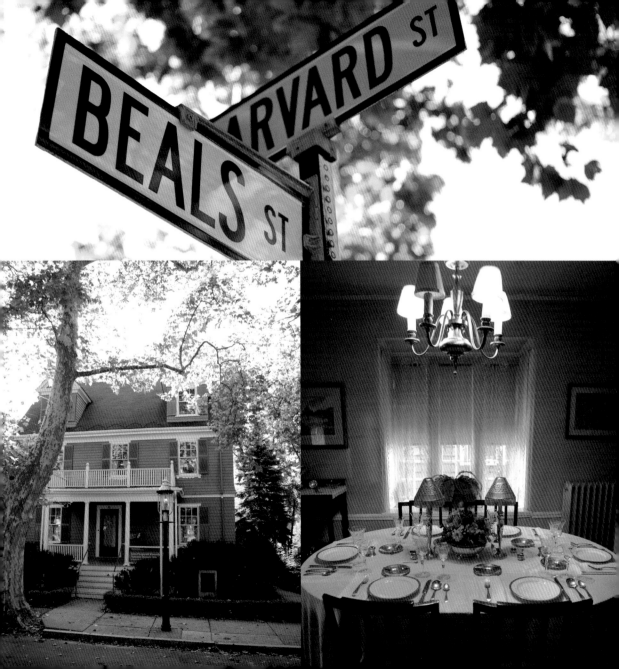

JOHN HANCOCK TOWER

First of all, there are two. The Old John Hancock building, down Saint James Avenue from the new building, is the (relatively) short, art deco stone structure with the pyramid-shaped roof and colored beacon at the top. The colored beacon indicates the weather: blue for clear weather, flashing blue for clouds, red for rain, and flashing red for snow.

The new John Hancock tower, completed in 1976, is the sleek, 60-story, 790-foot skyscraper in Copley Square built to house John Hancock Insurance. The company built the tower to be the tallest building in Boston, in competition with Prudential Insurance's already completed tower just blocks away.

The design by Henry Cobb proved quite successful, while the Prudential

The new John Hancock Tower stands at 241 meters (790 feet), making it the tallest building in Boston and the tallest building in New England. The tower's interior, including the observation deck on the 60th floor, has been closed to the public since September 2001.

tower did not. The Pru was lambasted for its mundane aesthetics, but the Hancock proved an elegant mirror for Trinity Church, Copley Square, and a placid sky on a summer day. The Hancock, however, was also plagued with structural problems—primarily, swaying of the upper floors and falling glass panes—which became a major embarrassment for the company.

Since the 1970s Bostonians have largely forgotten the structural failures, as well as John Hancock Insurance. Referred to as the John Hancock, it now represents the man more than the company, in the eyes of young residents—which is convenient, since Hancock, as a signer of the Declaration of Independence, was one of Boston's most famous residents.

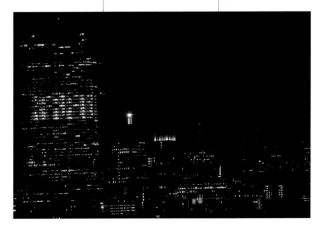

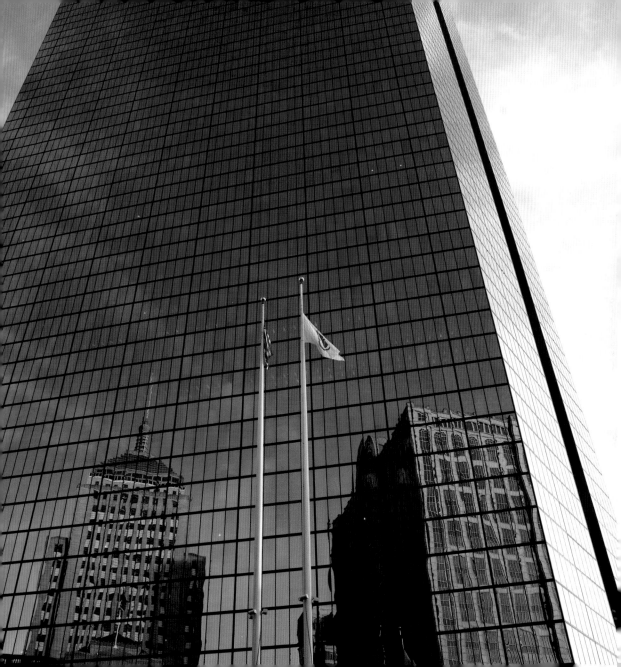

KING'S CHAPEL AND BURIAL GROUND

Just as the Granary Burial Ground preceded the Granary, the King's Chapel Burial Ground preceded King's Chapel itself. It is the oldest burial ground in Boston proper, home to the remains of 12-term governor John Winthrop (as well as his son and grandson), the Reverend John Cotton, William Dawes Jr. (who rode with Paul Revere), and Mary Chilton, the first female colonist to step off the Mayflower onto Plymouth Rock. The burial ground also contains the headstone of Elizabeth Pain, whose headstone inspired Nathaniel Hawthorne's *The Scarlet Letter*.

The chapel came second, in 1686, when King James II ordered the colonists to build a parish for the Church of England. No one would sell land for an Anglican church, however, so Royal Governor Sir Edmund Andros seized land from the burial ground. The original structure was a small wooden church at the corner of Tremont and School Streets. The stone structure that stands today

Chapel Burial Ground is the oldest burying place in Boston proper, unused since 1796. Built after the burial ground, the King's Chapel is located on the corner of Tremont and School Streets. For more information about the chapel, visit www.kings chapel.org.

was completed in 1754, literally built around the existing wooden building, which was then demolished, board by board, and removed through the windows of the new stone church.

The chapel hung its bell in 1772, but in 1814 it cracked. Paul Revere, whose handiwork is visible throughout Boston (e.g., copper sheeting for the hull of the USS *Constitution* and the dome of the Massachusetts State House), recast the bell, the last one cast by Paul Revere, which still rings today.

The congregation of the chapel lost support during the American Revolution, and it was left vacant, a period in which the building was known as the Stone Chapel. In 1782 it reopened under James Freeman, who revised the *Book of Common Prayer* to include Unitarian philosophies. Today the church still uses the *Book of Common Prayer: According to the Use of King's Chapel*, descended from Freeman's text, which combines Anglican and Unitarian philosophies.

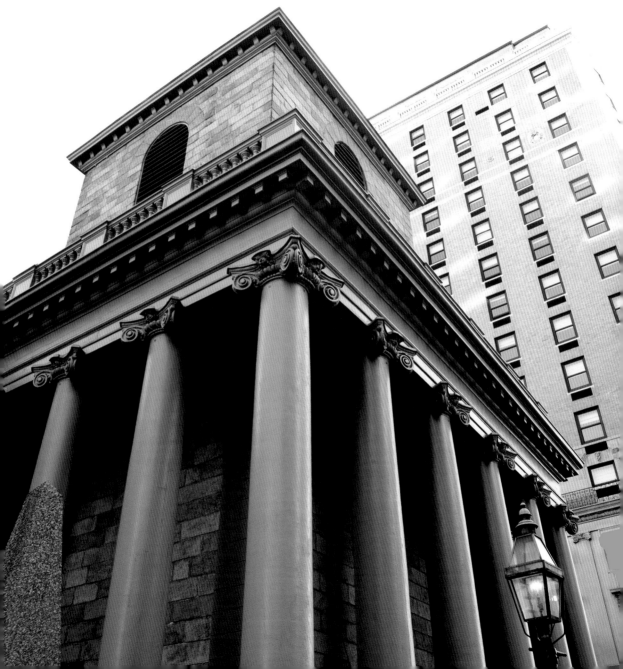

THE LONGFELLOW BRIDGE

The Longfellow Bridge was named after poet Henry Wadsworth Longfellow (who wrote "Paul Revere's Ride"). Longfellow wrote about the bridge in his 1845 poem "The Bridge"—or rather, he wrote about the West Boston Bridge, the predecessor of the Longfellow Bridge.

The West Boston Bridge, built at the end of the 18th century, replaced ferry service from Boston to Cambridge. Once completed, the new bridge spurred the growth of the previously sparse East Cambridge—new buildings, roads, and businesses spread out like a delta from the mouth of the bridge.

The Longfellow Bridge is iconic because of its role in connecting the two cities, but also because of its two central towers: quirky little towers with domes at the top that look like salt and pepper shakers. This is why most residents of Boston and Cambridge never refer to it as the Longfellow Bridge, but as the Salt-and-Pepper Bridge.

Every day 28,000 motor vehicles, 90,000 transit users, and significant numbers of pedestrians and bicyclists use this bridge to cross the Charles River.

Fortunately, the bridge is also going to receive an overhaul. It hasn't received major improvement work since it opened in 1906, but in 2008 Governor Deval Patrick passed funding for a $267.5 million rehabilitation. Ironically, this was the same summer that two state employees stole thousands of feet of decorative iron trim and sold it for scrap metal.

In some ways the Longfellow Bridge seems more Bostonian than some of its siblings, such as the Mass Ave Bridge or the Zakim. It has ornate stone features that attest to its age, but it also has a down-to-earth nickname; just as Boston has historical, magnificent buildings, such as the Boston Public Library or Trinity Church, but also a wide network of working-class and middle-class neighborhoods that support the city, like Roslindale and Jamaica Plain. The bridge has fallen into disrepair, as portions of the city often do, but Bostonians will revitalize it, as, hopefully, they will always do with their city, as well.

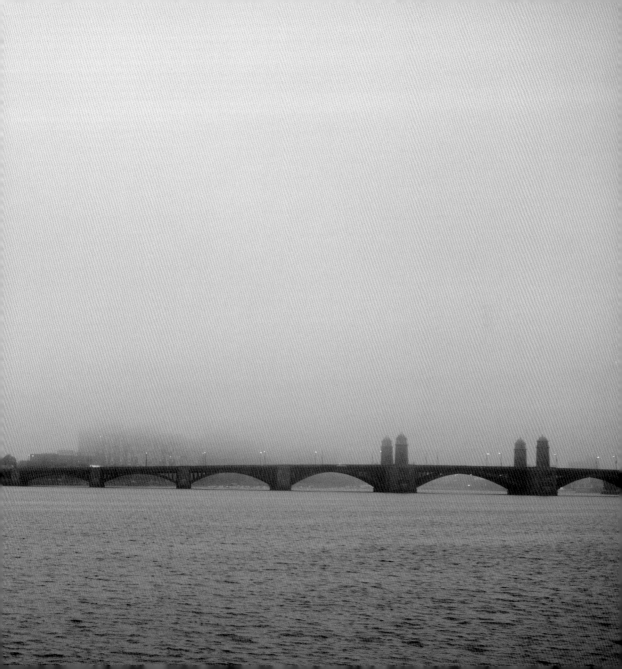

MAKE WAY FOR DUCKLINGS

Even if you're not from Boston, you've probably read *Make Way for Ducklings*. If you are from Boston, you definitely have. Robert McCloskey (who also wrote *Blueberries for Sal*) published the book in 1941, and it has remained in print ever since, selling over 2 million copies. The story, about a pair of mallards who form a family and settle in the Public Garden, originally achieved fame by winning the 1942 Caldecott Medal and through its appealing illustrations and memorable story line.

Since its publication the book has woven itself into the fabric of Boston culture itself. Its continued fame is still due to its appeal to readers, but also because of the support that Bostonians extended toward it. In 1987 the city installed a series of bronze statues in the Public Garden of Mrs. Mallard and her 8 ducklings—Jack, Kack, Lack, Mack, Nack, Ouack, Pack, and Quack. The statues, by sculptor Nancy Schön, remain brightly polished from the thousands of hands that pat the ducks every

Mrs. Mallard's Island can be found in the Boston Public Garden.

year and the children who ride them. And when people aren't surrounding the statues, the living ducks of the Garden will approach, pecking in the nearby grass for food.

Beginning in 1978, the city has hosted an annual springtime Duckling Day parade, recreating the route that Mrs. Mallard and her ducklings followed to find their new home in the Public Garden. In 2000 the book even became the official children's book for the Commonwealth of Massachusetts.

Make Way for Ducklings certainly would have remained a beloved story even if it hadn't taken place in Boston— just like *Blueberries for Sal* or other stories from the same era, such as *Goodnight Moon*. But now the story and the Public Garden are entwined; for every Bostonian they both are a fond memory, a common experience, a unifying narrative. It is impossible to separate the book from the city's history and lore—not that anyone would want to.

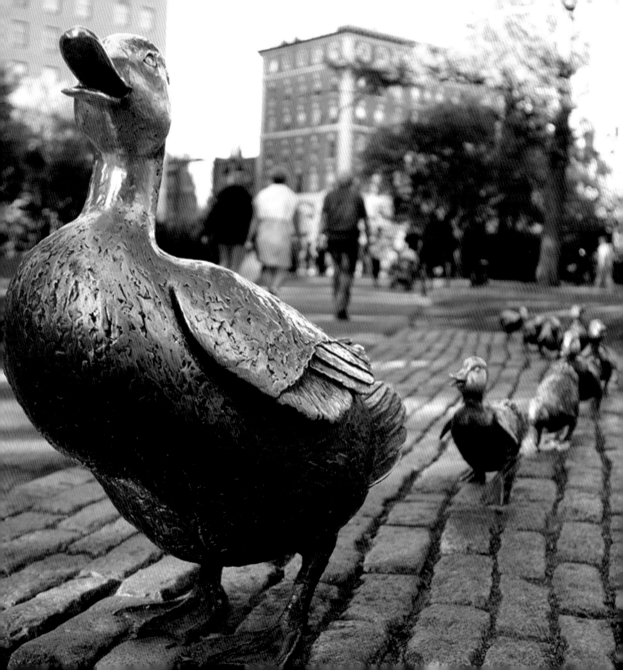

MASSACHUSETTS GENERAL HOSPITAL

𝓕ounded in 1811, Massachusetts General Hospital is the third-oldest hospital in the United States and currently one of its top ranked. It is a teaching hospital of Harvard Medical School and has the largest hospital-based research program in the country. Its list of accomplishments and honors runs long, but it is also an icon that represents a group of icons; just as Harvard and MIT represent the network of colleges and universities in Boston, MGH represents the biomedical industry that is a cornerstone of commerce, employment, and daily life in Boston. MGH alone is the largest nongovernmental employer in the city. With other hospitals such as Tufts Medical Center, Brigham and Women's Hospital, and Faulkner Hospital, and leading biomedical institutions such as the Whitehead Institute, Boston would crumple without the biomedical industry.

Located at 55 Fruit Street or on the web at www .massgeneral.org.

Massachusetts General Hospital itself is most famously known for its Ether Dome, a stadium-style lecture room in the Bullfinch Building, the original building designed by famed Boston architect Charles Bullfinch. On October 16, 1846, John Warren, the first dean of Harvard Medical School, performed surgery on Edward Abbott, a local printer, and used ether as an anesthetic for the first time in a public demonstration.

The Bullfinch Building still stands, with the Ether Dome perched above it, but the hospital has swelled around it. Now a complex system of buildings and departments, in addition to 7 satellite campuses, the main campus has over 900 beds and processes over 1 million outpatients every year. Over 3,000 new Bostonians are born there every year, and a fair share die there as well. As a financial, cultural, and intellectual building block of the city, it is the lifeblood of Boston.

MASSACHUSETTS INSTITUTE OF TECHNOLOGY

MIT began in 1861 with a charter from the Commonwealth of Massachusetts for the "Massachusetts Institute of Technology and Boston Society of Natural History." Scientist William Barton Rogers, who submitted the charter, proposed a new vision for university education, one that embraced three principles (known as the Rogers Plan): the value of utilitarian knowledge, the importance of hands-on experience for the educational process, and the integration of a technical educational format with a liberal arts format.

MIT held its first classes in 1865, on newly formed land in Back Bay. Today it occupies a sprawling campus in Cambridge along the Charles River, with 5 schools, 1 college, and 32 academic departments. It is one of the world's preeminent educational and research institutions—a reputation that it has earned over the past century due in part to its involvement in military and government research, such as the Manhattan Project and the development of the Semi-Automatic Ground Environment (SAGE), a tracking system.

Find out more at http://web.mit .edu/.

MIT generally makes headlines in the *Boston Globe* for three reasons: scientific achievement, student suicide, and school pranks. The first is self-explanatory; the second is an unfortunate product of a high-pressure institution, and one that MIT has been addressing since this issue came to light in the 1990s and 2000s; the third, strangely, contributes to MIT's reputation for collecting the world's geniuses, in that clever pranks don't demonstrate wickedness as much as ingenuity and intelligence. Recent exploits include the upside-down room at the Wiesner building in 2009 or the musical notes placed on the Great Dome in the same year.

As with Harvard University MIT does not stand alone. While it is an institution of excellence, it also draws upon the collective strengths of Boston: its vast network of universities and colleges, robust biomedical industry, and culture for supporting the arts and sciences. That is one reason that citizens of Boston and Cambridge are so proud of MIT: because they all, in part, helped build it.

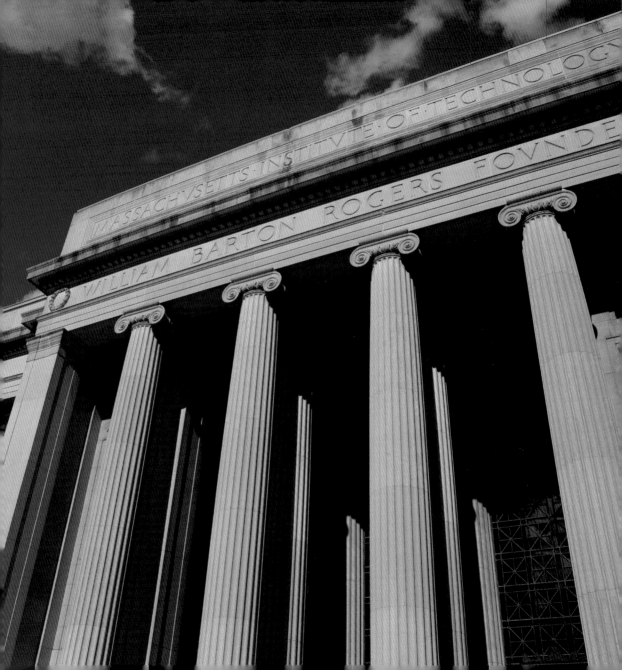

MASS AVE BRIDGE

There is a bridge stretching across the Charles that connects Back Bay in Boston to Cambridge, at the edge of the MIT campus. Massachusetts Avenue, or Route 2A, runs over its length, which is why many Bostonians call it the Mass Ave Bridge. They also call it the MIT Bridge, since it points directly to that university. And strangely, few people call it by its real name, the Harvard Bridge. (It was also once called the Xylophone Bridge, back when it contained wooden decking and cars would create a unique sound when driving over.)

Built in 1891 and named after the Reverend John Harvard, famous contributor (but not founder) to Harvard University, the bridge is a stalwart element of Boston's and Cambridge's geography. Whether driving

from one city to the other or bicycling along the Esplanade, the MIT Bridge will be in your view—modestly, since it has no towers and sits low over the Charles, but constantly.

The bridge is the longest bridge over the Charles River, measuring 364.4 smoots, plus or minus one ear. It sounds almost macabre out of context, but residents of Boston and Cambridge wouldn't blink twice at this measurement. One smoot equals 5 feet 7 inches, the height of Oliver R. Smoot, a fraternity pledge at MIT's Lambda Chi Alpha in 1958. The story goes that Smoot lay on the bridge from end to end, marking the length of the bridge in chalk and paint. The bridge is still marked in smoots, repainted each year by members of Smoot's fraternity.

MUSEUM OF FINE ARTS

The Museum of Fine Arts (MFA) was founded in 1870, partly in collaboration with members of the Boston Athenaeum, in response to Boston's need for a separate, independent museum of art. The museum originally opened in 1876 in Copley Square (current location of Trinity Church and the Boston Public Library) and moved to its current location by the Fens in 1909.

Since its conception the museum has become one of the largest art museums in the United States—with over 450,000 works of art and more than 1 million visitors each year. It is also notable for its renowned associations: With the opening of the museum in 1876, the founders also launched the School

Open 7 days a week, the Museum of Fine Arts is located at 465 Huntington Avenue; get more information at www.mfa.org.

of the Museum of Fine Arts, which now runs in collaboration with Tufts University; in 1999 the museum also launched a sister museum in Nagoya, Japan, in partnership with the Foundation for the Arts in Nagoya.

The museum's collection is too vast to list, of course. Some of its most prominent exhibits include its renowned collection of Egyptian artifacts, its large collection of Japanese works, and its French Impressionist or post-Impressionist works from artists such as Van Gogh and Renoir. In 2010 the MFA also launched the New MFA, a recent addition that expands the museum's galleries and educational facilities and includes a new wing for contemporary art.

MUSEUM OF SCIENCE

When you mention the Museum of Science, Bostonians of a certain age will think of Leonard Nimoy of *Star Trek* speaking the lyrics to "Who Put the Bomp." Nimoy, who grew up 3 blocks from the museum, helped record the introduction to the Mugar Omni Theater, a domed IMAX theater with steep stadium seating and a 180-degree screen.

The theater, a nonprofit organization featuring films of scientific and educational interest, is a relatively recent attraction; the origins of the Museum of Science go back to 1830, with the founding of the Boston Society of Natural History. The society, devoted to collection and research, eventually opened the New England Museum of Natural History in 1864 in Back Bay.

After nearly a century the society decided to expand and moved to its current location at Science Park, a stretch of land that straddles the Charles River. The society signed a 99-year lease with the city and opened its first wing of the new museum, now called the Boston Museum of Science, in 1951.

Appropriately, the Museum of Science is located at 1 Science Park in Boston. Visit the website at www.mos.org.

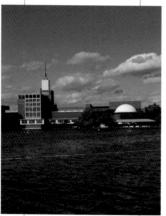

The museum now boasts over 500 exhibits dedicated to all fields of science, as well as 100 animals (often rescued and rehabilitated), the Mugar Theater, and, perhaps most famously, the Theater of Electricity, which houses the world's largest Van de Graaff generator. Designed and built by Dr. Robert Van de Graaff himself, who was a professor at MIT, the generator creates electrostatic voltages on large metal globes—voltages as high as 2 million volts. The generator was originally used for research into atom-smashing and X-ray technology, but when newer technology became available for this research, Van de Graaff donated his creation to the museum in 1956, where it now stands, two stories tall, for daily lightning shows.

Like the New England Aquarium and the Museum of Fine Arts, the Museum of Science provides the city with a rich and diverse resource for education, research, and curiosity. Because of its existence, the population of Boston is certainly a little bit smarter.

NEW ENGLAND AQUARIUM

The first aquarium in Boston—in fact, the first stand-alone aquarium on record—was the Boston Aquarial Gardens on Bromfield Street, near Downtown Crossing. This short-lived ancestor of the New England Aquarium boasted 40 tanks of 20 or 30 gallons, plus 1 larger octagonal tank that housed a pair of sturgeons and a family of perch. Admission was 25 cents for adults and 15 cents for children.

Two other aquariums rose and fell before 1969, when the New England Aquarium opened its doors to the public. With its mission "to protect the blue planet," the New England Aquarium has redefined what a modern aquarium can accomplish. The building on Central Wharf is only a fraction of the aquarium's network, which extends around the world in the form of research, community outreach, education, conservation, and rescue. For example, the aquarium responds to distress calls in New England for stranded marine mammals. It collaborated with other conservation organizations on the Phoenix Islands Protected Area, and in

Located at 1 Central Wharf; www.neaq.org.

1994 it launched the groundbreaking Women in Science program, connecting middle-school girls with female scientists at the aquarium.

These are only a few of its many accomplishments. The aquarium itself is impressive enough, for its sea lions, anemone, urchins, and penguins and for its Giant Ocean Tank—a 4-story, 200,000-gallon saltwater tank holding sharks, eels, and over 600 other creatures, including its most famous inhabitant, Myrtle the sea turtle. Myrtle has lived at the aquarium since June 1970. She is over 70 years old, weighs over 500 pounds, and swims in calm, majestic spirals around the Giant Ocean Tank at the aquarium's center.

Thus the aquarium is a living museum, a school, a laboratory, a hospital, a theater, and so many other things. It plays diverse roles around the world in oceanic research and conservation. In those roles it is also a comforting guardian of Boston Harbor, looking out on the waters that it is sworn to protect and looking inward toward downtown Boston, the city it is sworn to serve.

NORTH END

Every neighborhood or town in the Boston metropolitan area is burgeoning with history—Beacon Hill, Back Bay, Brookline, Charlestown, South Boston. Each could (and does) fill pages. The North End, however, is the city's oldest neighborhood, dating back to its original settlement in the 17th century.

Everyone knows the North End for its Italian-American population, clearly reflected in the storefronts on Hanover Street: Mike's Pastry and Modern Pastry, competing for cannoli sales; Caffe Paradiso, with its homemade gelato; the stores and shops selling imported olive oil or wine. What not everyone knows is that the North End has hosted many of Boston's immigrant populations: the original settlers, former slaves, the 19th-century wave of Irish, Jews, and now, Italians.

An elevated highway, Interstate 93, used to separate the North End from the rest of the city—an unwieldy, unat-

Visit www.north endboston .com for more information.

tractive, and sometimes dangerous barrier against accessing the enclave. The Central Artery/Tunnel Project (better known as the Big Dig), however, sought to improve this situation by sinking the highway and building a greenway above it. The country knows the Big Dig as one of the biggest public works projects ever attempted—with a total cost of $22 billion, according to the *Boston Globe*, and a duration of 16 years, from 1991 to 2007. The Big Dig itself became mired in controversy caused by evidence of shoddy work, fraud, legal disputes, even the death of a woman from Jamaica Plain when a ceiling collapsed in 2006.

The vision of the Big Dig, however, has manifested: a waterfront region unthreatened by dangerous traffic or a lurking highway framework. The North End again feels like part of the city—which, of course, it always has been; now we can simply see it better.

OLD NORTH CHURCH

The Old North Church—properly known as Christ Church—opened its doors on December 28, 1723, making it the oldest surviving church in Boston. Its steeple, at 191 feet, is the tallest steeple in Boston, but the Old North Church is most famous for its role in Paul Revere's ride on April 18, 1775.

On the night Paul Revere set out to cross the Charles River and ride to Lexington to warn John Hancock and Samuel Adams of the approaching British army, Revere first met with the sexton of Old North Church, Robert Newman. Newman's duty was to hang two lanterns from the steeple of the church to forewarn patriots in Charlestown that the British were arriving by sea (because of this warning and the warnings of the first riders—Paul Revere and William Dawes—by the end of the

Part of the Freedom Trail and still an active congregation; learn more at www.oldnorth .com.

night, there were actually up to 40 riders spreading news of the approaching redcoats).

Newman only hung the lanterns for less than a minute, to avoid notice by British troops already stationed in Boston. But his signal reached the patriots in Charlestown. Interestingly, the church itself remained largely loyal to the British crown. The congregation consisted mostly of loyalists, including the Royal Governor of Massachusetts. One of the 8 bells, cast in 1744 and hung in 1745, even bears the inscription: "We are the first ring of bells cast for the British Empire in North America, A.R. 1744." Thus in context Newman took action for the Sons of Liberty with an especially high risk for his own welfare, immortalizing the Old North Church as a beacon of liberty in the canon of Boston.

OLD SOUTH MEETING HOUSE

If the walls of the Old South Meeting House could talk, they would tell a story that every student of American history has heard: the story of the Boston Tea Party. On December 16, 1773, about 5,000 Bostonians met at the meeting house to discuss taxation by the British government, especially the Tea Act of 1773. Colonists objected to the Tea Act in part because of their overall objection to taxation without representation—they believed that only their elected representatives should have the right to levy taxes upon them.

On the evening of December 16, Samuel Adams said to the crowd, "Gentlemen, this meeting can do nothing more to save the country." This prompted the crowd to surge to Boston Harbor, where dozens of men, some disguised as Mohawk Indians, boarded the *Dartmouth*, the *Eleanor*, and the *Beaver*, the East India Company's cargo ships moored at

Located at 310 Washington Street and part of the Boston Freedom Trail; learn more at www.oldsouth meetinghouse .org.

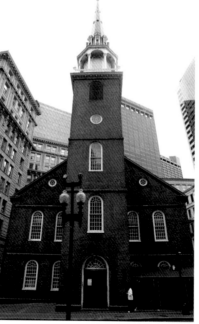

Griffin's Wharf. The men dumped 342 crates of tea, 45 tons of it, into Boston Harbor, spurring retaliation from the British Government in the form of the Coercive Acts, which, in turn, prompted the First Continental Congress and events leading to the American Revolution.

Thus, if the walls of the meeting house could talk, they could tell this story more accurately than anyone today could. They could answer questions to which we don't know the answers, such as the location of Griffin's Wharf or whether Samuel Adams's words were really a secret signal to the Sons of Liberty. They could tell other stories, too: of the British soldiers who gutted the building and filled it with dirt to practice horse riding, of thinly surviving the Great Boston Fire of 1872, of Boston's evolution from a town in which the meeting house was the largest structure to the city that dwarfs it today.

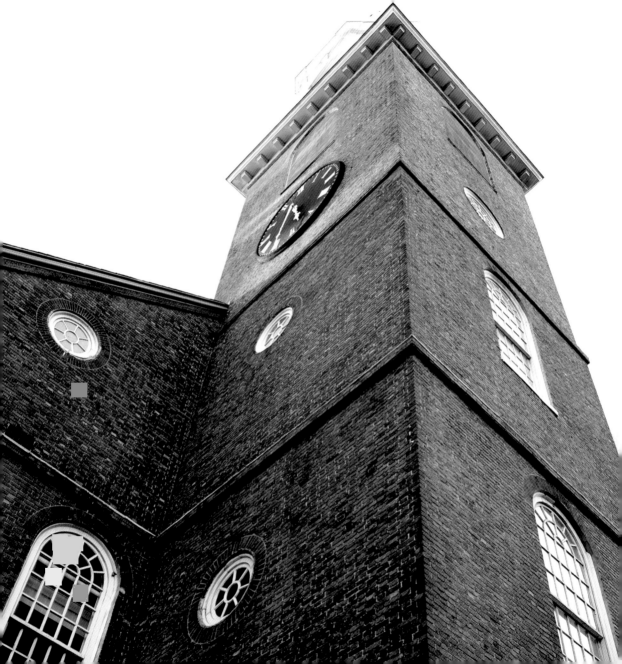

OLD STATE HOUSE

The Bostonian Society, a non-profit organization for the preservation of the Old State House, states in its history of the building that "history happened here." Like so many of Boston's iconic buildings, the chronology of the Old State House reads like a chronology of colonialism and revolution in the New World.

Built in 1713—making it the oldest surviving public building in Boston—the building originally housed warehouses in the basement, a merchant exchange on the first floor, and government offices on the second floor. The building has entered the national historical canon because of the many key moments that occurred in or outside the building: For example, the Declaration of Independence was proclaimed to the population of Boston in 1776, and prior to that the Boston Massacre of 1770 occurred on its doorstep.

The Boston Massacre was the result of a riot between citizens of Boston and British military soldiers, or redcoats, stationed there. The event began as a small incident on King Street (now State Street) but eventually grew to a full

Just down the street from the Old South Meeting House at 206 Washington Street. Visit www .bostonhistory .org for more information.

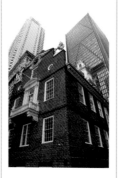

riot with a crowd of hundreds. As the incident grew unruly and then violent, the redcoats fired their muskets into the crowd, striking 11 citizens and killing 5. (Interestingly, the famous patriot John Adams represented the 8 soldiers accused of murder, because he believed in due process and the right to a fair trial.)

The Boston Massacre proved to be a monumental incident leading to the American Revolution, especially considering that, as massacres go, this one was rather small. At the Jamestown Massacre of 1622, for example, 347 settlers died at the hands of the Powhatans. Both incidents, however, caused incendiary reactions afterwards—evidence that the significance of a tragedy depends upon the population's reaction as much as or more than the incident itself.

The Old State House, of course, simply witnessed these events. It did not play a direct role—the Boston Massacre would have happened whether or not the State House was standing there—but that is how buildings work; they are quiet observers, synecdoche for the historical events that transpire around them.

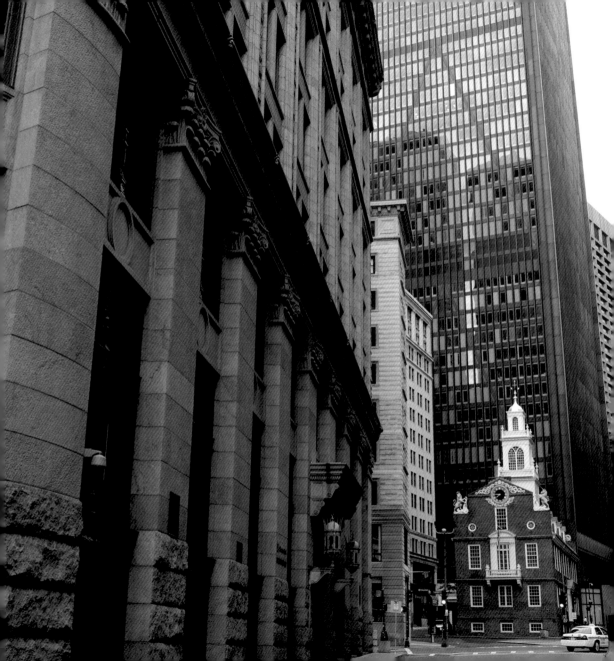

PARK STREET CHURCH

The Park Street Church came into existence when 26 Christians, many of them former members of the Old South Church, came together and planned a new church devoted to Trinitarian orthodoxy (in a time when the Unitarian movement was gaining momentum). Founded in 1809 and built in under a year, the church has an immediate, visceral prominence in Boston because of its 217-foot steeple, but it has also played a valuable role in Boston's religious and cultural history.

The Park Street Church organization calls itself "a church of firsts," due to the historical precedents that occurred there: One of the country's first Sunday school programs began there in 1816; abolitionist William Lloyd Garrison delivered his first antislavery address there in 1829; and the hymn "America" by Samuel Francis Smith, which became "My Country 'tis of Thee," was first

Learn more about Park Street Church's past and present at www .parkstreet.org.

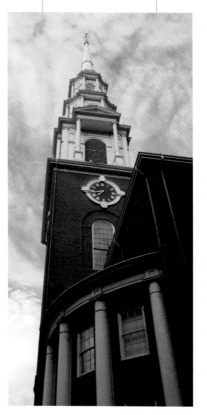

sung by the church's Children's Choir in 1831.

Ironically, Bostonians know the intersection of Tremont and Park Streets, where the church stands, as Brimstone Corner, likely because the church housed gunpowder during the War of 1812 and possibly because of the church's missionary bent. The church's history is long and storied, and it even sits upon the site of older Boston lore: To build the church its makers tore down the Old Granary Building (built in 1728, it lends its name to the neighboring Granary Burial Ground), where the sails for the USS *Constitution* were sewn.

Today, though the church has stirred some controversy from its support of conversion therapy, among other policies, overall it serves as an essential force in the community, participating in educational programming, community service and outreach, and assistance to underserved groups.

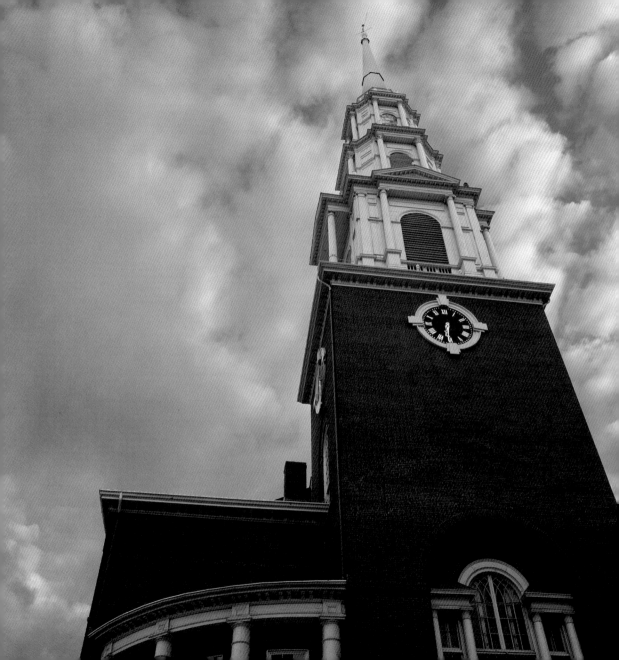

PAUL REVERE HOUSE

The 3-story house at 19 North Square in the North End is rather unassuming: a plain wooden structure rather typical of 17th-century architecture. The building has two primary claims to celebrity: It is the oldest surviving building in downtown Boston, and it was owned by Paul Revere, who bought it in 1770 for 53 pounds, 6 shillings, and 8 pence with a mortgage of 160 pounds.

Born in Boston's North End, Revere was a prominent silversmith and patriot who helped form the alarm system for possible attacks by the British military. In 1774 and 1775 the Boston Committee of Correspondence and the Massachusetts Committee of Safety hired Revere as a rider to deliver news to locations in Massachusetts or even as far as New York City or Philadelphia. This is, of course, what made Revere famous: his midnight ride to Lexington, Massachusetts, on April 18, 1775, to warn Samuel Adams and John Hancock that British troops were arriving to arrest them.

There were three riders: Revere, who crossed the Charles River to Charlestown; William Dawes, who took a separate route; and, later, Dr. Samuel

Learn about downtown Boston's oldest building at www.paul reverehouse.org.

Prescott. It's also important to note that Revere never shouted the famous words, "The British are coming!" His mission depended upon secrecy, since the British army had soldiers stationed throughout Massachusetts.

Paul Revere's house serves to immortalize this watershed moment in American history, as does the Paul Revere Monument, a statue of Revere during his midnight ride that sits behind the Old North Church, not far from the Revere House. But it is the words of Henry Longfellow that ultimately immortalized the incident in his poem "Paul Revere's Ride," excerpted here:

So through the night rode Paul Revere;
And so through the night went his cry of alarm
To every Middlesex village and farm,—
A cry of defiance, and not of fear,
A voice in the darkness, a knock at the door,
And a word that shall echo for evermore!
For, borne on the night-wind of the Past,
Through all our history, to the last,
In the hour of darkness and peril and need,
The people will waken and listen to hear
The hurrying hoof-beats of that steed,
And the midnight message of Paul Revere.

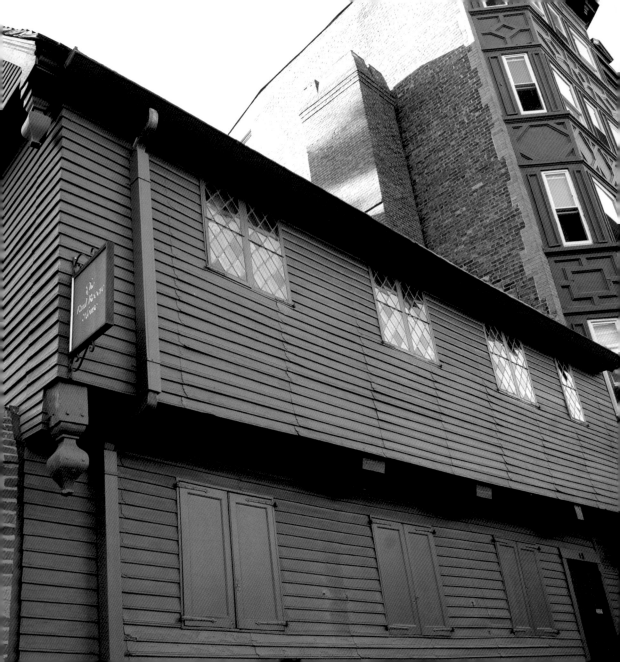

PRUDENTIAL TOWER

The Prudential Tower's initial claim to fame was its height of 749 feet. At its completion in 1964, it was the tallest building in the world outside New York City and the tallest building in Boston. John Hancock Insurance, a rival of Prudential Insurance, endeavored to eclipse the Prudential Tower in 1976 with the completion of the John Hancock Tower. Despite their former rivalry, however, the two buildings now seem quite cooperative: Only blocks away from each other in Back Bay, they have become the primary anchors in the Boston skyline.

The Prudential Tower, familiarly known as the Pru (which, coincidentally, is also its stock abbreviation on the New York Stock Exchange), has not always been a well-loved anchor of the Boston skyline, however. When it opened in 1964, it received praise from some critics, but others, especially residents, con-sidered it an ostentatious and ill-fitting addition to the city. *Boston Globe* architecture critic Robert Campbell would even dub certain buildings in Boston as the worst buildings of the year—an honor that he called the Pru Awards.

The Prudential Tower and its surrounding Prudential Center, located at 800 Boylston Street, are currently owned by Boston Properties. Its original owner, Prudential Insurance (now Prudential Financial) has since sold the building, as well as other Prudential towers and properties around the country, including air rights in Times Square, New York City.

Loved or hated, the Pru isn't just part of the Boston skyline—it is the skyline. It's like family, in a way: You can't change your family, and even if you could, ultimately, you love them as they are.

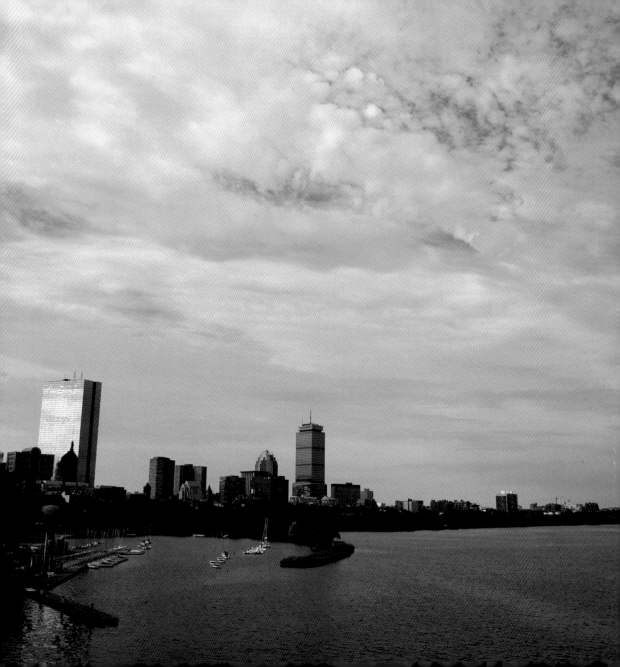

QUINCY MARKET

Quincy Market rests on land that didn't exist until the 1630s. After Boston was founded in 1630, the residents began to fill in the tidal flats of what was known as Town Cove. Landfill continued until 1870, resulting in Boston's current shoreline, and the effort created the land now occupied by Faneuil Hall, Quincy Market, and parts of the North End and the Financial District.

When it was built between 1824 and 1826, Quincy Market itself stood at the harbor's edge. Built by architect Alexander Parris, with aid from Mayor Josiah Quincy, after whom the building is named, Quincy Market was a response to Boston's growing commercial needs—since Faneuil Hall could no longer meet the demands of space from vendors and customers.

In the 19th century the market served as a stockhouse for food and supply merchants, as well as a shopping center for staples such as poultry, bread, and cheese. The building—two stories, made from New Eng-

land granite and red brick—still bears advertisements from early merchants on the walls beneath the central dome.

The marketplace no longer sits on the harbor's edge (more landfill extended the shoreline in later years), and the merchants have changed drastically—ice cream, clam chowder, knickknacks, sushi, paratha, and candles—but Quincy Market still serves the same purpose. The vendors line the walls of the market inside and out, and Bostonians and tourists alike fill the long, central hallway, sniffing for what will satisfy them.

Quincy Market doesn't stand alone, either—it is surrounded by Faneuil Hall, North Market, South Market, and the large cobbled plaza where magicians and street performers attract crowds of hundreds. Its popularity and incredible foot traffic make it even more strange, then, that only 400 years ago, when you visited the site of the current Quincy Market, you were standing in water.

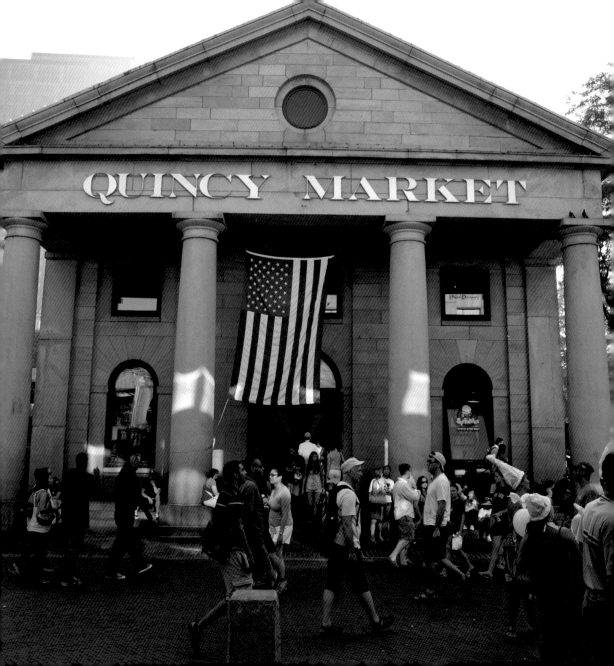

RED SOX NATION

You will never understand the fervor of a Boston fan until you witness it in person. The zealous energy Bostonians expend for all their teams—Celtics, Bruins, Red Sox, Patriots—could fuel the city for an eternity. And the heroes of these sports are legion: Larry Bird, Bill Russell, Kevin Garnett, Kevin McHale, Josh Hannah, Nick Buoniconti, Mike Haynes, Tom Brady, Bobby Orr, Ray Bourque, Bill Cowley.

Yet you will hear the fever pitch of Boston fandom at its absolute maximum on opening day at Fenway Park, when the Red Sox begin a baseball season—or at any Red Sox–Yankees home game. This is why Boston is often called Red Sox Nation, by Bostonians and outsiders alike.

Until 2004 loving the Red Sox was an exercise in hope and disappointment. Founded in 1901 as one of the first 8 teams in the American League, the Red

Sox began their career on top. They won the first World Series in 1903 against the Pittsburgh Pirates and then 4 more times up to 1918, when they defeated the Chicago Cubs.

In 1918, however, the Red Sox traded Babe Ruth to the New York Yankees, initiating an 86-year drought of World Series titles. Fans blamed the "curse of the Bambino" for the Red Sox's streak of disappointments, until, knock on wood, the curse was broken in 2004 when the Red Sox defeated the St. Louis Cardinals.

For Boston fans, in the end, it doesn't matter if the Red Sox win or lose—or rather, it matters immensely, but Boston fans will be Boston fans either way. They love the Red Sox because they love the Red Sox. No matter what their record, Boston fans will always fill Fenway Park and keep their eye on the Green Monster, hoping for the baseball to clear it.

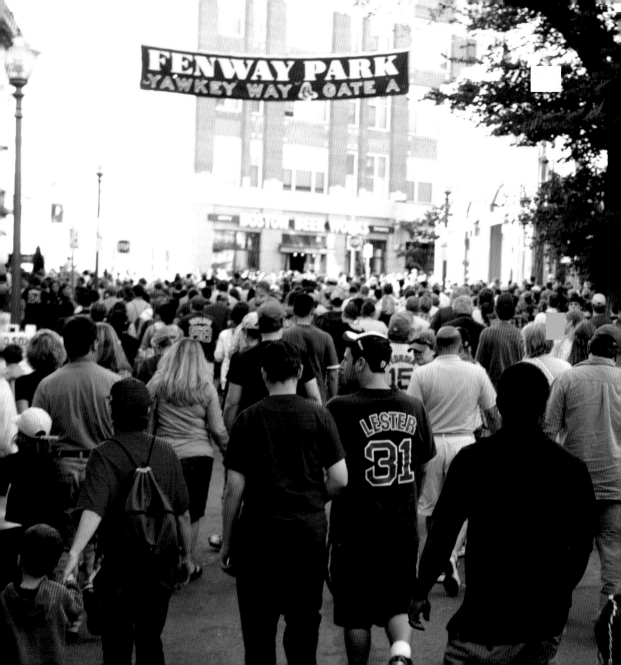

SAMUEL ADAMS BREWERY

The history of Boston is synonymous with the history of the United States: It is difficult to walk the streets of Beacon Hill or the waterfront without encountering statues of the Founding Fathers, plaques attesting to Revolutionary battles, or gravestones of the men and women who helped form this country. Thus it is a testament to the Samuel Adams Brewery that its Boston Lager has become nearly as iconic as the brewery's namesake.

Samuel Adams, the Founding Father, played an essential role in the American Revolution. Born and raised in Boston—he attended the Boston Latin School and Harvard College—Adams fueled the Revolution by opposing taxation without representation; later he attended the Continental Congress in Philadelphia, signed the Declaration of Independence, and contributed to the Articles of Confederation and the Massachusetts Constitution.

It is the revolutionary spirit of the man that the beer strives to emulate: According to Jim Koch, founder of the Boston Beer Company that produces

For information about tours visit www.samuel adams.com.

Sam, the domestic beer market was in a sad state in 1984 when he first made lager beer in his kitchen, using his grandfather's old recipe. Domestic beers had turned to mass production, and craft beers were just emerging as an alternative. The beer made its debut in April of 1985, and by 1988 the company had opened its Boston Brewery, was selling 36,000 barrels a year, and was distributing to both coasts.

Today the Boston Brewery location still operates—primarily for Samuel Adams's well-attended daily tours and tastings and as a laboratory for experimental concoctions. The unanswerable question, of course, is whether Samuel Adams beer would have become such a household name had it not chosen one of America's most famous revolutionaries for its name. Boston touts plenty of excellent beer companies, such as Harpoon and the Cambridge Brewing Company, but Sam Adams has one of America's pioneers on the label, and with his image the brewery has also borrowed some of his legend.

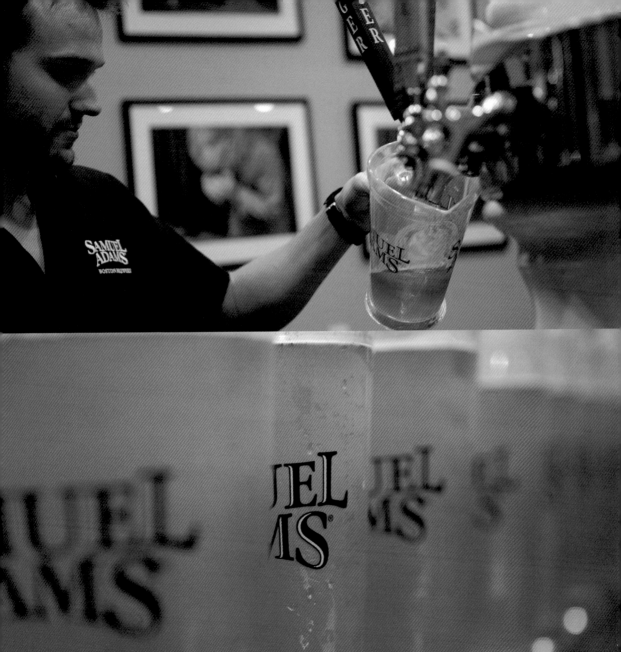

STATE HOUSE

It's telling of Massachusetts's deep historic roots that the "new" State House was completed in 1798. The old State House along State Street, another icon of Boston, was built in 1713 and still stands today. The new capitol, designed by famed Boston architect Charles Bullfinch, stands on land once owned by John Hancock, the state's first elected governor, famed patriot, and signer of the Declaration of Independence.

Located across from Boston Common atop Beacon Hill.

The entire history of the new State House, in fact, reads like a list of celebrities from Massachusetts history: Paul Revere's company was responsible for covering the original wooden dome with copper; statues on the lawns include Daniel Webster, Horace Mann, and John F. Kennedy; and of course, its halls have witnessed some of the greatest triumphs and debacles in Massachusetts politics—protests leading up to the Massachusetts Supreme Court decision to allow same-sex marriages in 2004, protests against Boston's controversial busing program for racial integration in 1974, and the rise of William Bulger, former president of the State Senate and brother of James "Whitey" Bulger, famed crime boss and wanted criminal. The State House is also the home of the Sacred Cod; although many Bostonians might not know its origin, it is famous for hanging above the chamber of the House of Representatives (the cod was given to the house in 1784 as a gift from a local merchant to signify the importance of the fishing industry to Boston's economy).

The red-brick building sits on 6.7 acres in the Beacon Hill neighborhood, one of Boston's oldest neighborhoods, with Federal-style row houses and gaslit streetlamps. Its prominent position makes it visible from the Public Garden, the Charles River, and Cambridge. Like the Citgo sign, its bright gold dome (signifying that a president of the United States came from the state) acts as a visual epicenter for the skyline of Boston—as well as the city's political and geographic center.

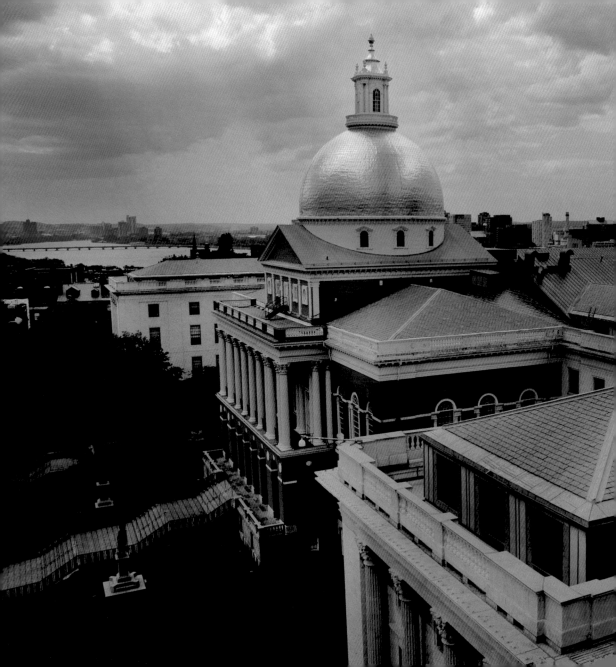

THE T

You can always recognize Bostonians in New York or Paris or other cities because they will identify the trains by their color. In New York, instead of the "N-Q-R line," a Bostonian will call it the "yellow line." Or in Paris, instead of the 7 train, a Bostonian will call it the "pink train."

The Massachusetts Bay Transit Authority (MBTA, or simply "the T," as it is known) operates the trains of Boston's subway system, with its 4 brightly colored lines: red, blue, orange, and green—in addition to the silver line, the commuter rail, the bus system, and ferries. The MBTA's domain (over 200 routes and lines spanning 175 cities and towns and an area of 3,244 square miles) results from the efforts of private companies in the 19th and early 20th centuries that slowly built and expanded Boston's transportation system. The Metropolitan Transit Authority, a political body of the Commonwealth of Massachusetts, came into existence in 1947, taking over many of the private interests—two of which were the Park Street and Boylston Street stations, the two oldest subway stations in the country. The MBTA succeeded the

The official website for information about the T is www.mbta.com.

MTA in 1964, charged with expanding and unifying the transportation needs of Boston and its outlying cities and towns.

If you visit Boston today, to enter the subway or ride the bus, you first have to purchase a Charlie card—a paper or plastic card with a saved value on it. And Charlie, as every student in the Boston school system has learned since the 1950s, is a man who "never returned" because he didn't have the fare to get off.

This, of course, makes no sense. In Boston riders pay to get on the train, not off. But in 1949, after the MTA started charging passengers an extra nickel to exit trains that stopped above ground, Walter A. O'Brien protested the fare hike in his run for mayor. The Charlie song was recorded for O'Brien's campaign, among others, and even became a hit song in the 1950s.

Today the MBTA transports over 1 million riders every week. It has evolved from a horse-and-buggy system in the 19th century to a fast-pumping circulatory system for the Boston metro region, run on electricity, gas, and diesel. And nowadays, don't worry about riding the train, bus, or ferry—it's free to get off.

TRINITY CHURCH

In the 1870s when Trinity Church was built, it was one of the tallest buildings around, at 211 feet. Since then office buildings and condominiums have sprouted around it, including the John Hancock Tower and the Prudential. Instead of dwarfing Trinity Church, however, these buildings serve to highlight the building's architectural magnificence by contrast; its clay roofs and heavy arches seem all the more grand and permanent when reflected in the glass and steel of the John Hancock building.

Consecrated in 1877, the church is a member of the Episcopal Diocese of Massachusetts. The building itself made many of its contributors famous in their own circles, such as Henry Hobson Richardson, the architect, and John La Farge, one of the artists who contributed to the interior and stained glass (Richardson even launched a new style of architecture with

Learn more about historic Trinity Church at www .trinitychurch boston.org.

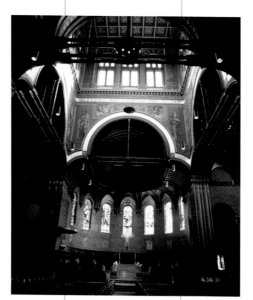

Trinity Church, called Richardsonian Romanesque).

The stained glass windows are one of the church's most notable features. When the building opened, it had only one stained glass window—the Baptism window in the chancel. But since then the windows have slowly been replaced with different panels from multiple artists in the 19th and 20th centuries, making the collection of windows an eclectic group—like a slideshow of stained glass art over the past century and a half.

The American Institute of Architects deemed Trinity Church one of the "Ten Most Significant Buildings in the United States," and in 1970 it became a National Historic Landmark. Its neighboring skyscrapers are taller, certainly, but in grandeur and longevity, the church still manages to dwarf them.

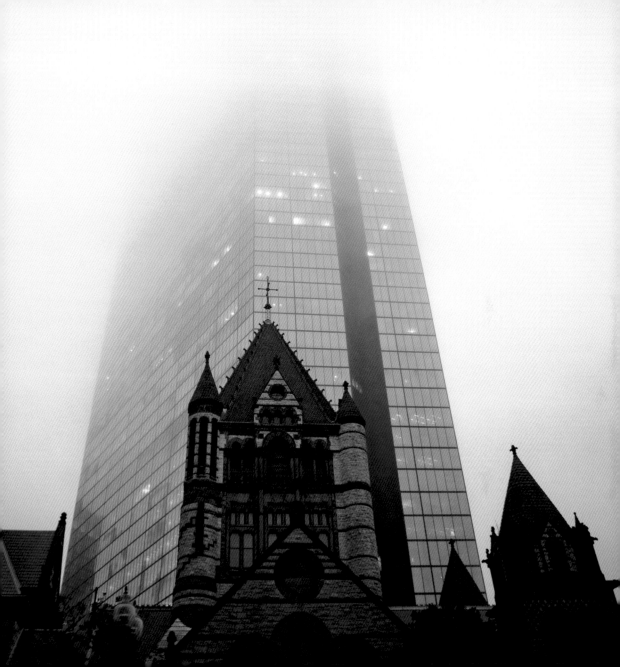

UNION OYSTER HOUSE

The building predates the Oyster House. Built in the early 1700s, the building housed Hopestill Capen's fancy dress shop in the 1740s, known as "At the Sign of the Cornfields"; In 1771 Isaiah Thomas used the second floor to print the *Massachusetts Spy*, the oldest newspaper in America. The building hosted the paymaster of the Continental Army during the Revolutionary War, and in 1796 the future king of France, Louis Phillippe, lived in exile on the second floor, giving French lessons to earn a living.

The building became a National Historic Landmark in 2003, in no small part because of its longest occupant, the Union Oyster House. The oyster house opened to customers in 1826 as the Atwood and Bacon Oyster House,

Located at 41 Union Street on the historic Freedom Trail. Visit www.union oysterhouse .com for more information.

making it the oldest restaurant in America. In 1830 the owners installed the famous semicircular oyster bar, a massive stone slab used for storing and shucking oysters that still exists today. (Amazingly, according to the Union Oyster House's history, the restaurant has operated under only three owners since 1826.)

The lore of the oyster house, beyond its age, involves its former customers. Daniel Webster, the lawyer and statesman, used to order a tall brandy and water with a half dozen oysters (often giving this order at least 6 times in a sitting). John F. Kennedy used to frequent Union Oyster as well, preferring the upstairs dining area, where there is now a booth dedicated to his memory.

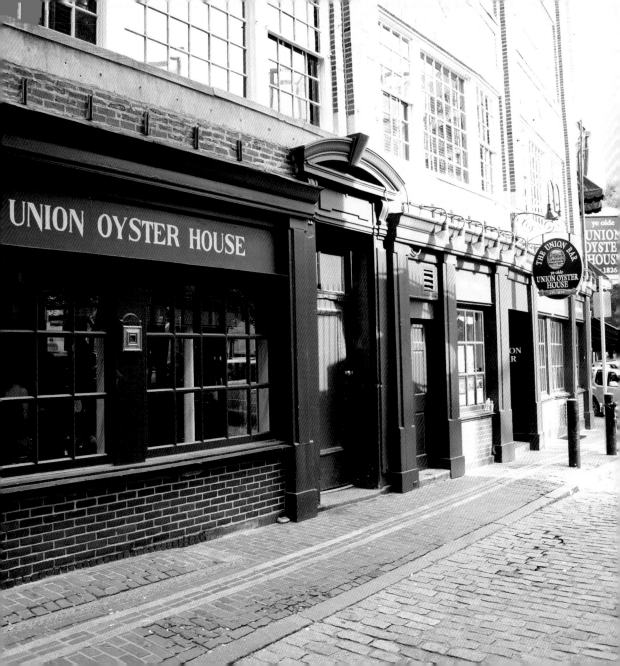

USS CONSTITUTION

Kids in Boston might not recognize the name USS *Constitution*. They usually know the ship by her familiar name, Old Ironsides. No one refers to her as the USS *Constitution* except when narrating for tourists or a history class.

Old Ironsides is the world's oldest commissioned naval vessel still afloat. She is a 44-gun heavy frigate with a wooden hull and 3 masts, completed by 1798. The wood for her construction came from all over North America but included a good proportion of southern live oak from Georgia, an especially dense wood—for a ship with an especially thick hull (21 inches instead of the more common 18 inches). Paul Revere, a famous metalworker as well as a patriot, provided the copper bolts and breasthooks.

Old Ironsides earned her name during the War of 1812 against the British, when she confronted the British warship HMS *Guerriere* off the coast of Nova Scotia. The *Constitution* took fire from the *Guerriere*, but she destroyed

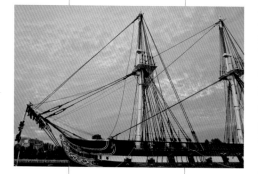

the British ship and remained relatively unscathed, as if her flanks were made of iron—thus the nickname.

Old Ironsides is such a sturdy ship, in fact, that it took a month to launch her into the water. At her planned launch on September 20, 1797 (with President John Adams in attendance), she slid 27 feet down the ways before grinding to a halt. A second attempt moved her slightly closer to the water, but again, her weight depressed the ways into the ground. A month later the navy finally succeeded in getting the ship into the water.

The USS *Constitution* still sits in the harbor today, at the Charlestown Navy Yard. She was retired in 1881, but in 1997, for her 200th birthday, she sailed again under her own power—a widely attended event in the Boston area, ensuring that the name Old Ironsides will continue to inspire the hearts and imaginations of Bostonians for decades to come.

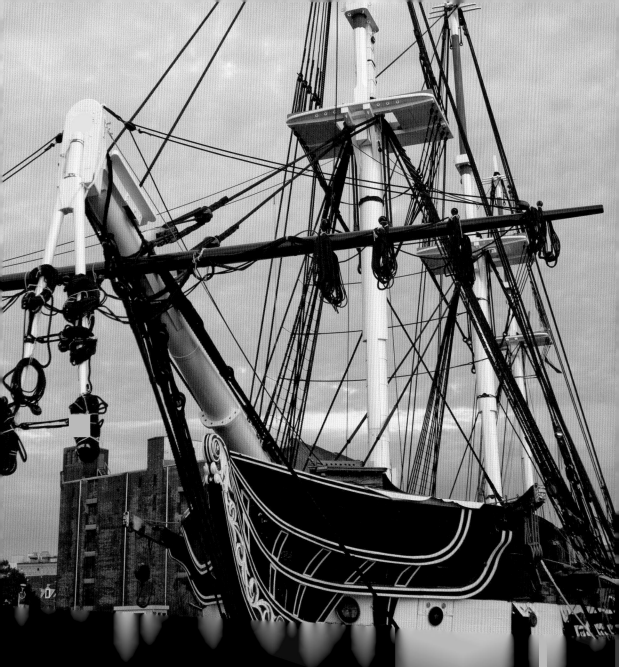

WALDEN POND

"I went to the woods because I wished to live deliberately, to front only the essential facts of life, and see if I could not learn what it had to teach, and not, when I came to die, discover that I had not lived."

— *Henry David Thoreau*

Without Thoreau's book Walden, Walden Pond would be just another Boston-area body of water, like Fresh Pond, Jamaica Pond, or Lake Quannapowitt. Walden's only other claim to fame is as one of the sources of ice for "Ice King" Frederic Tudor, an early-19th-century businessman who founded an ice exportation company that shipped blocks from the frozen ponds around Boston to distant locations such as India and the Caribbean.

But it was Thoreau, not Tudor, who made the pond famous (it is even a National Historic Landmark). Thoreau, born in Concord, Massachusetts, moved to the shores of the pond in 1845 and built a small cabin, where he lived for the next two years as an experiment in simplicity and self-sufficiency.

This project, and the resulting book, established Thoreau as one of

the country's eminent naturalists, and made Walden Pond the icon of anti-industrialism, environmentalism, conservation, and pure living—sometimes mistakenly so. The book *Walden*, while often an ode to nature, was simply a transcendental experiment, Thoreau's attempt to move away from society to understand it better. Walden Pond, for example, was at the edge of town, not in an isolated woodland as some now believe, and Thoreau often received visitors—which contradicts the misconception of a hermitlike existence.

Today Walden Pond is a popular swimming hole in the summer and a natural reserve year-round. While it's an active part of modern life in Concord and Boston, it has comforting, eclectic ghosts of the region's past: the ghost of the glaciers that formed the pond; the ghost of Frederic Tudor, who appeared thousands of years later to harvest a different kind of ice; and, of course, the ghost of Thoreau, who, we hope, presides happily over his famous little pond.

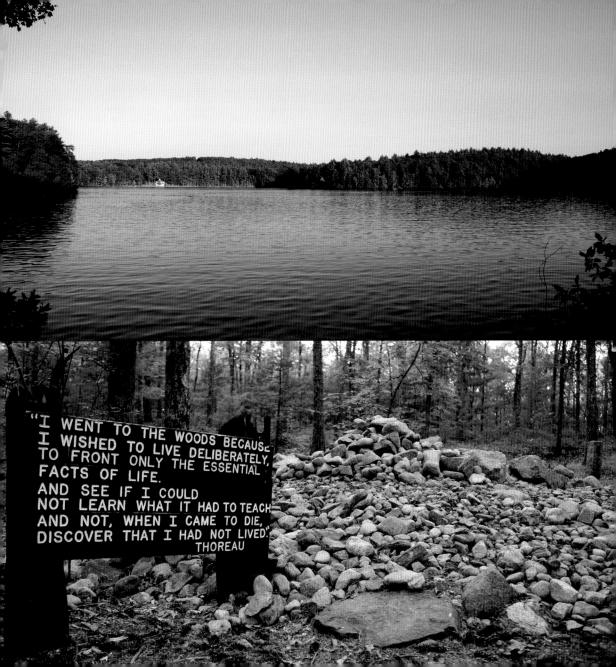

ZAKIM BRIDGE

The Leonard P. Zakim Bunker Hill Memorial Bridge is a mouthful. Bostonians call it simply the Zakim Bridge. It is also quite young—completed in 2003 as part of the Big Dig, the largest highway construction project in the United States. In Boston many icons are hundreds of years old—or at least several decades. The Zakim bridge, however, quickly became synonymous with the Boston skyline. Like the Sydney Opera House for Sydney, Australia, or the Golden Gate Bridge for San Francisco, the Zakim is becoming a symbol of Boston itself.

The bridge, a 10-lane cable-stayed bridge, replaced the older Charlestown High Bridge. It carries traffic along Interstate 93 and Route 1, which feed out of Boston to

Learn about the bridge and its part in the Big Dig at www.leonard pzakimbunker hillbridge.org.

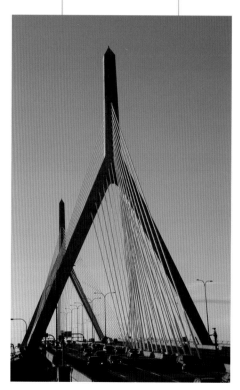

points north, such as New Hampshire or Walden Pond, and points south, such as the Blue Hills. The bridge honors Leonard Paul Zakim, civil rights activist and the director of the New England office of the Anti-Defamation League of B'nai B'rith. It also honors the soldiers who fought in the Battle of Bunker Hill, which gives rise to its second shorthand moniker, the Bunker Hill Bridge.

The High Bridge, built in 1954, was never intended to handle the traffic load that it eventually bore. By 2003 when the Zakim Bridge opened, the High Bridge certainly showed signs of wear and age. It was demolished in 2004, and in its place the city built a $96 million public park as part of the Rose Kennedy Greenway.

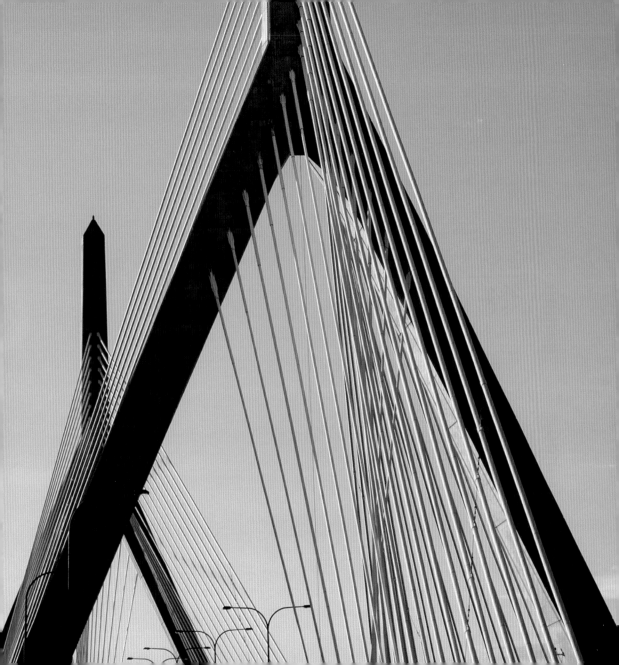

ABOUT THE AUTHOR

Jonathan Scheff is a writer, photographer, and teacher. He lived in Brookline, Massachusetts, until he was 18 years old; after that he spent his time exploring the rest of the world. In 2010 he retired a pair of sandals that had walked in over 20 countries. He lives in New York City with his dog, Loki.